TRAFFORD PARK
FROM OLD PHOTOGRAPHS

TRAFFORD PARK
FROM OLD PHOTOGRAPHS

KAREN CLIFF AND PATRICIA SOUTHERN

AMBERLEY

First published 2008

Amberley Publishing Plc
Cirencester Road, Chalford,
Stroud, Gloucestershire, GL6 8PE

www.amberley-books.com

British Library Cataloguing in Publication Data.
A catalogue record for this book is available from the British Library.

ISBN 978 1 848 68 081 4

Typesetting and origination by Diagraf (www.diagraf.net)
Printed in Great Britain

Contents

Introduction

The industrial complex known as Trafford Park was one of the first and one of the largest in Europe. It is inextricably related to the two canals that surround it – the eighteenth-century Bridgewater Canal to the south and the larger nineteenth-century Manchester Ship Canal to the north. It was a truly symbiotic relationship: without the canals, the industrial complex could not have been developed or sustained, and without the industries of the Park, the canals would not have been successful. Happily, much of the Park is still active today, having pulled back from the decay that threatened to set in during the 1970s. The fact that it survived and resurfaced is due to the energies of the various official bodies and personnel that worked hard to save the area and the industries. In its heyday, before and during the two world wars, the Park was a significant feature in many people's lives; it is probably true that everyone in the Greater Manchester area was either employed in one of the factories, or knows someone who worked in Trafford Park at some time or other. Statistics of employees are staggering when compared to modern figures, and the support industries that backed up the Park – such as transport facilities for goods and people – also provided many more jobs.

This book is by no means a comprehensive history of the Park – this task has been fulfilled by Robert Nicholls among other authors – but it provides glimpses of the various phases of the development of Trafford Park, from the establishment of the canals, through the growth and demise of the stately home that gave the Park its name, to the foundation of the many factories, starting with the famous British Westinghouse – this was one of the first vast establishments, better known by its later name, affectionately truncated to Metro-Vicks. The intention of this book is to revive people's memories and tell part of the story of how the Park developed, what it was like to work there, and what happened to it in the end. At every stage, it is a story of human endeavour and achievement.

Karen Cliff and Patricia Southern,
Trafford Local Studies Centre,
Trafford Libraries.

Acknowledgements

The authors would like to thank several people who have helped us in producing this book. These include: Matthew McKenny at Cerestar, Trafford Park, for sharing knowledge and information; Gary Cliff for encouragement and transport; and Sefton Samuels FRPS, H. Steer, Robert Nicholls and Dr Michael Nevell for permission to use photographs. Most of the photographs in this book are from the photographic archive of Trafford Local Studies Centre, and we are grateful to Trafford Metropolitan Borough for granting permission to reproduce them.

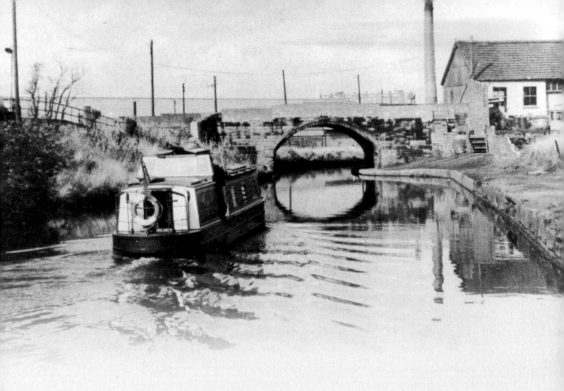

Chapter 1
The Coming of the Waterways

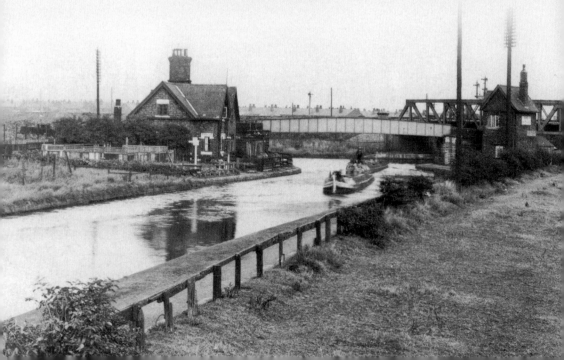

'Trafford Park is in fact an island bordered by the Ship Canal and the Bridgewater Canal'. This is how the area was described in the *Bicentenary Handbook of the Bridgewater Canal*. The waterways were the lifeblood of Trafford Park. It is true to say that this huge industrial complex would never have existed without the canals and the massive potential that they afforded, in the transport of raw materials inwards and finished goods outwards.

Transport by water was, of course, hardly a new idea. Many of Britain's rivers were navigable for some miles inland, and important ports had grown up around them to take advantage of the facilities for bringing in commodities from overseas and shipping out exports. But river transport was not without its problems: from flooding after heavy rains, from tidal action, from droughts in summer, and from silting. The last problem was one of the most serious because it gave rise to shifting channels and sometimes caused complete blockage of the rivers. Chester, for instance, lost most of its trade due to silting up of the river Dee, and the port of Liverpool took precedence thereafter.

Liverpool was able to exercise a virtual monopoly on seagoing trade by charging tolls for the use of its port and docks. The growing town of Manchester, about forty miles inland, developed an ongoing rivalry with Liverpool for what seemed like crippling expenses, which could be avoided if Manchester had its own access to the sea and its own port. There was a route to the coast via the rivers Irwell and Mersey, but it was hardly a navigable one for the transport of goods. The rivers were subject to the usual problems of flooding and drought, and the twists and turns that made the journey extremely long and very slow. It was possible to sail up the Mersey as far as Warrington, but thereafter the only alternative was to convey goods via land transport, which was notoriously difficult and slow, and also expensive. Improvement was necessary if Manchester was to enjoy the benefits of trade, and as early as the 1600s ideas were put forward to make the Mersey and Irwell navigable. These plans fell into abeyance until 1720, when finally the Mersey and Irwell Navigation Act was passed.

This project was welcomed by the Manchester businessmen because it linked them with the sea and provided cheaper transport. Take up was slow, however, and though the work could have started in 1721, nothing much was done for another three years. Even then, once the work had been done to straighten out the loops to shorten the journey and to provide locks, weirs and landing places, it was about a decade before larger ships of up to fifty tons in capacity began to be used on the journeys to and from Manchester. The fifty-ton limit was imposed by the size of the Calamanco Locks at Irlam, and another limitation was imposed by the variability of the water supply in the two rivers. Droughts in summer and floods in winter caused the boatmen tremendous problems – lack of water brought progress to a halt, too much water endangered not only progress but also lives. Even when water should have been in abundant supply, levels could be lowered if the installations on the river-banks took too much water for their industrial processes. In order to combat this problem of low water, the Mersey and Irwell Navigation ships, called 'flats', were of a very shallow draught. Though they had sails and could take advantage of any winds, the boats were more often pulled along by men or by horses.

It took about thirty years for the Mersey and Irwell Navigation to show any sort of profit, and by this time another water transport scheme was about to start. This was the lifelong project of Francis Egerton, the Third Duke of Bridgewater. The Duke had inherited his title at the tender age of twelve, and had also inherited the ideas of his predecessor, Scroop

Egerton: to make the Worsley Brook navigable and to join it to the Irwell. An act was passed in 1737, but the scheme was never realised. The need for water transport and for improved land transport was firmly embedded in the minds of the Manchester businessmen, however, as evidenced by the succession of projected schemes in the 1750s. The 1753 Turnpike Act was designed to improve the road from Salford to Warrington, which reduced transport costs and forced the Mersey and Irwell Navigation to lower its charges. In 1754, the Manchester businessmen put forward an idea for a canal from Wigan to Salford, but it came to nothing. The following year, an act was passed to canalise the Sankey Brook from St Helens to the river Mersey. This navigation opened in 1757.

In that same year the Third Duke of Bridgewater appointed John Gilbert as his agent at Worsley, where he owned lucrative coal mines. A scheme for another canal was probably already being discussed at this point. As a coal owner, the Duke of Bridgewater realised that Manchester and the surrounding areas were growing as industries developed, and the inhabitants and the industries needed fuel. The first of the Canal Acts was passed in 1759, presumably after much preliminary work had been done to survey routes and to make plans. The original route for the canal was planned to run north of the river Irwell, but as early as 1760, this had been changed. The new plan involved taking the canal across the Irwell by means of an aqueduct, which was designed by James Brindley, but probably constructed under the guidance of John Gilbert. This route involved the Trafford family, since the canal would cross their estate, passing through Trafford Moss. As a by-product of the cutting, the moss could be drained, so it is perhaps unlikely that the de Traffords opposed the act of 1760 that brought the canal to their lands, though some sources state that they did raise objections. The problem is that there is no record either to prove that they welcomed the project or were antagonistic towards it.

Work on the aqueduct began in 1761, and originally the canal reached as far as Stretford. A succession of acts was passed to make extensions to the canal – to Manchester in the east, to Runcorn in the west, and from Worsley to Leigh. By the 1780s, boats were sailing regularly between Manchester and Runcorn, pulled by horses walking along the towpaths, with stabling at depots for changes of animals. It took about eight hours to travel from Manchester to Runcorn, leaving at 8.30 a.m. and arriving at 4.30 p.m. – a vast improvement on road transport or via the 'flats' of the Mersey and Irwell Navigation. The latter enterprise was now under threat and tried to sell out to the Bridgewater, but the offer was refused. The only choice was to improve the river route, making new cuts to join up loops in the rivers and rebuilding locks. Thus the two waterways operated in conjunction or in competition for several years.

The Trafford family came into conflict with the Bridgewater Canal Co. in the 1820s, mainly because of flooding. The arches of Brindley's aqueduct carrying the canal across the Irwell were too narrow when the river was in spate, and as a consequence the Trafford lands were often flooded. The problem was solved in 1838 by constructing a weir and escape channel to carry the excess water back to the River Irwell near Urmston.

From the 1830s onwards, serious competition arose for the Bridgewater Canal and the Mersey and Irwell Navigation, in the form of the new-fangled railways. The canal and the navigation struggled on, but there was another problem in that the Mersey was subject to silting, and eventually it was so severe that the channel was blocked and only small craft

could get through. In 1872, the Bridgewater Navigation Co. was formed, with the object of taking over the Mersey and Irwell Navigation, revamping it and dredging the channels. But there were plans in the making that would change the face of transport to and from Manchester.

From the mid-nineteenth century onwards, there had been more than one suggestion for a canal to Manchester that could carry large ships. In 1882, there was a historic meeting at the Didsbury home of Daniel Adamson, where on his initiative, and that of other influential Manchester men, the Manchester Ship Canal was born. It was not an easy passage. The first bill presented to Parliament in 1883 was passed by the Commons but rejected by the Lords. Opposition came from the de Traffords, who objected to the proposed canal because it would bring pollution near their lands (though in fact the canal was to run north of the River Irwell, giving the de Traffords more land on their northern boundary). The following year the bill was passed by the Lords, but rejected by a Select Committee of the House of Commons. Finally, in 1885, the necessary act allowing the construction of the canal was passed. Within a year, Sir Humphrey de Trafford died and the estate passed to his son, Sir Humphrey Francis de Trafford, who was willing to sell parts of his land. In 1889, some of the estate was sold to make room for Davyhulme Sewage Works, and then lands on the northern border of the estate were sold to enable docks and wharves to be built on the new canal.

The Manchester Ship Canal was opened in 1894, amidst all due pomp and ceremony, and Queen Victoria was in attendance. Within two years, the Trafford lands had been sold. The Manchester Corporation wanted to turn the estate into a leisure park for the growing population, but the industrialisation of the whole area was about to begin. A Derbyshire businessman, Ernest Terah Hooley, bought the park in 1896, and in August of that year the Trafford Park Industrial Estate was formed. Hooley met up with the manager of the Manchester Ship Canal, Marshall Stevens, and must have been impressed with him, since he made him manager of the Trafford Park Industrial Estate in 1897. While visitors to Trafford Park could still enjoy walking in the grounds and boating on the lake, factories were built and the first firms began to encroach on the southern parts of the estate, near the Bridgewater Canal. It was the start of a famous and long-lived relationship: the canals could not have survived without the purchase of the lands and establishment of the factories, and the factories could not have been established without the assurance of transport provided by the canals.

Opposite above: Sketch plan of the Bridgewater Canal showing the proposed extension from Altrincham to Liverpool. The canal crosses the River Irwell and proceeds through Trafford Moss, which is named on the plan. Also shown is Trafford House, situated near the River Irwell. The house and grounds are almost entirely surrounded by waterways.

Opposite below: The Bridgewater Canal skirting Water Meetings Farm in 1890. Moss Road, here a narrow country lane, is shown running from the south under the railway to the bridge across the canal. (Reduced from Ordnance Survey map, sheet CIII.16, surveyed in 1888 at 25 inches to one mile).

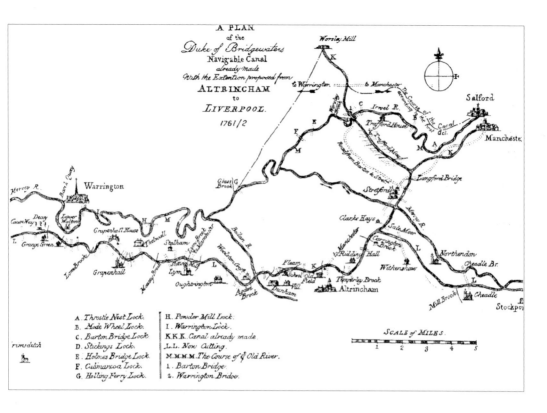

A PLAN
of the
Duke of Bridgewaters
Navigable Canal
already made
With the Extention proposed from
ALTRINCHAM
to
LIVERPOOL.
1761/2

A. Throstle Nest Lock.
B. Mode Wheel Lock.
C. Barton Bridge Lock.
D. Stickings Lock.
E. Holmes Bridge Lock.
F. Culmancoa Lock.
G. Holling Ferry Lock.
H. Powder Mill Lock.
I. Warrington Lock.
K.K.K. Canal already made.
L.L. Now Cutting.
M.M.M.M. The Course of y.º Old River.
1. Barton Bridge.
2. Warrington Bridge.

SCALE of MILES.
1 2 3 4 5

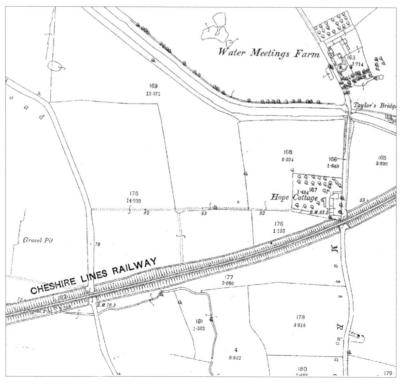

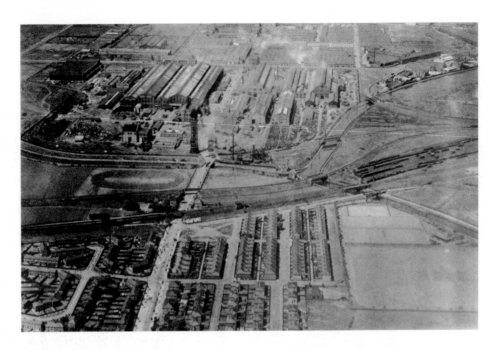

Above: An aerial view of the Bridgewater Canal at Water Meetings, where the two arms of the Bridgewater come together (the name was changed later to Waters Meeting). The photograph was taken looking down Moss Road towards the water tower and works of the Metropolitan-Vickers Electrical Co. Ltd. This firm, under its original name of British Westinghouse Electric & Manufacturing Co. Ltd. was one of the first to be established in Trafford Park, in 1899. Its parent company was Westinghouse of America.

Below: A closer view of Moss Road and Waters Meeting, and the Metropolitan-Vickers factory.

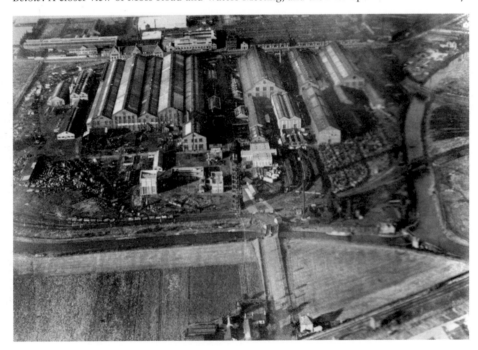

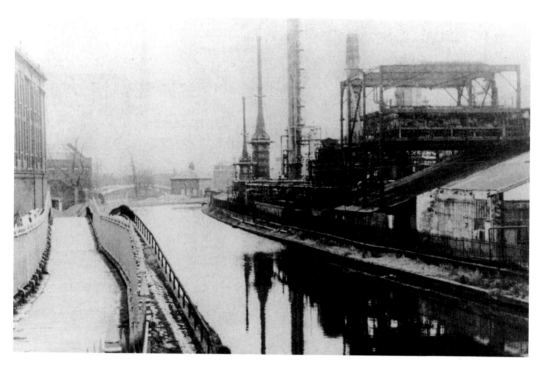

The Bridgewater skirting Trafford Park.

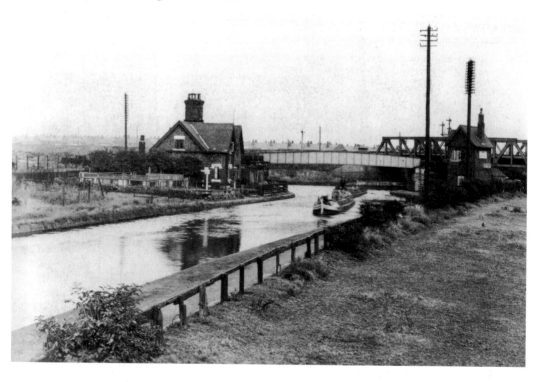

Barges at Waters Meeting.

In addition to its role in the transport of goods, the Bridgewater also fulfilled another role as a route for pleasure cruises. This boat is approaching Cornbrook Bridge, crossing the boundary between Old Trafford and Hulme.

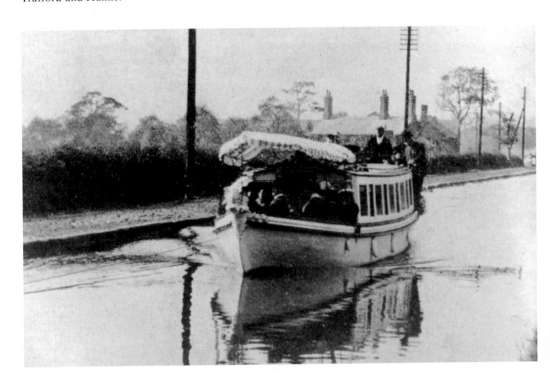

The Earl of Ellesmere's barge on a summer outing on the Bridgewater Canal.

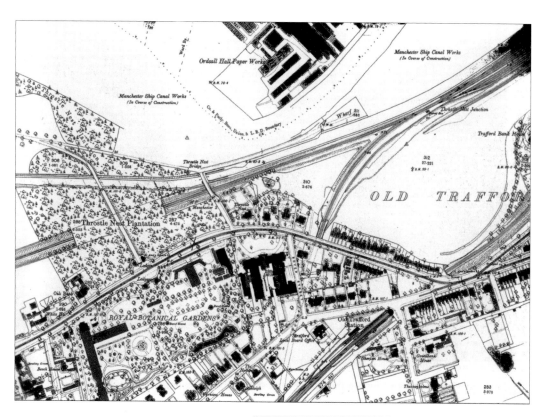

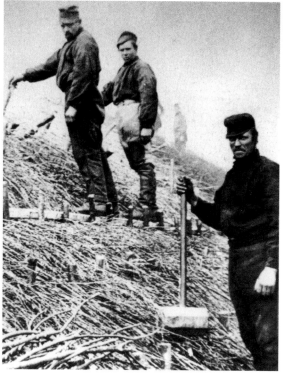

Above: This reduced section from an Ordnance Survey map (sheet CIV.13, first edition, surveyed in 1889 at 25 inches to one mile) predates the opening of the Manchester Ship Canal. It shows the Bridgewater Canal, and very close to it the proposed route of the Ship Canal, which was then 'in course of construction'. The two canals and the railway all converge at this point, at the 'elbow' of the Ship Canal. (Courtesy of Ordnance Survey).

Right: Workmen securing the banks of the Ship Canal.

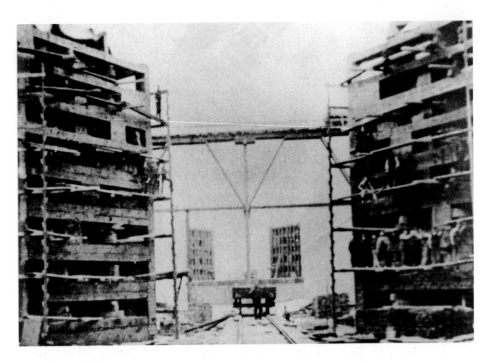

Lock gates under construction on the Manchester Ship Canal.

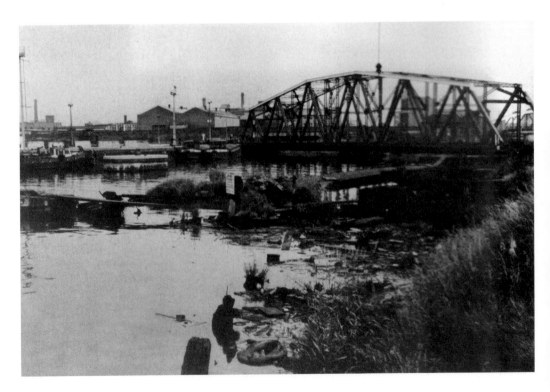

The swing railway bridge, with Trafford Road Bridge just visible on the right of the photograph.

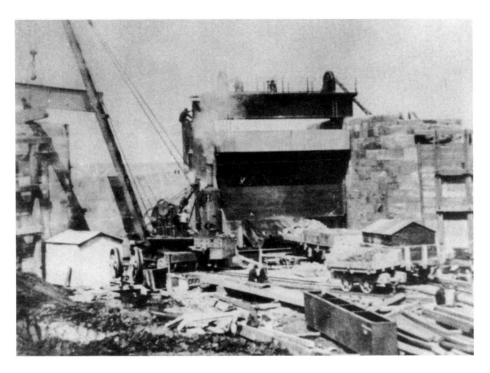

Sluice gate under construction for the Ship Canal.

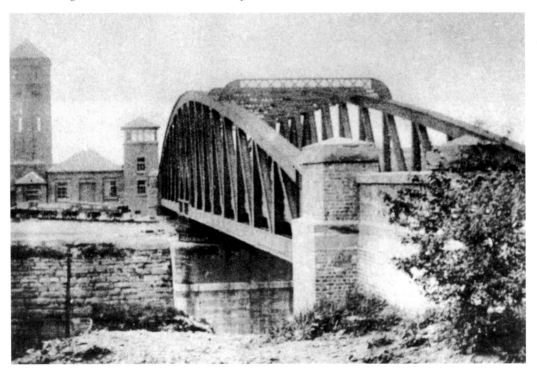

Moore Lane swing bridge.

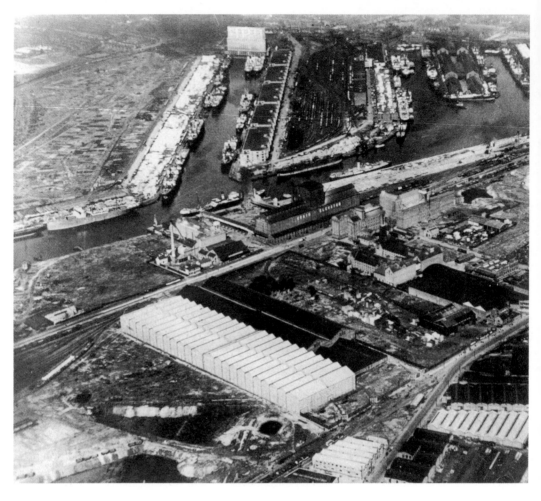

Aerial view of Trafford Park taken around 1925, showing Trafford Wharf and Salford Docks.

Opposite above: This photograph shows the Bridgewater Canal and the Manchester Ship Canal, with the Trafford Road swing bridge in the foreground. At the top left of the photograph, part of the Manchester United football ground can be seen, and running from the corner of the football ground is Warwick Road North, carried across the Bridgewater Canal on its single-span bridge. Almost at the top edge of the photograph, between the two canals, is the power station, with steam or smoke coming out of the building. Opposite the power station is the factory of Hall & Pickles, which produced steel tools and wire. In this sector of Trafford Park, the factories included the Co-operative Wholesale Society, N.Kilvert & Sons Ltd (manufacturers of lard), Lancashire Dynamo & Crypto Ltd, and the warehouses of the Liverpool Warehousing Co. Ltd.

Opposite below: The port of Manchester was vital to the success of Trafford Park. In the 1930s, it was stated in an advertising drive for Trafford Park that 'the terminal facilities at the Manchester Docks are probably unequalled in any other port in the world, every device saving time and labour being installed'.

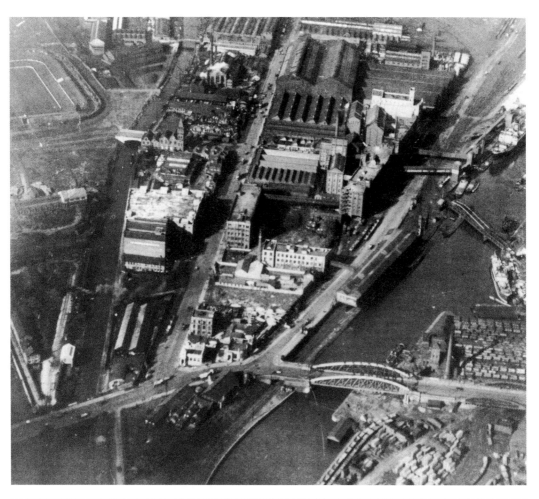

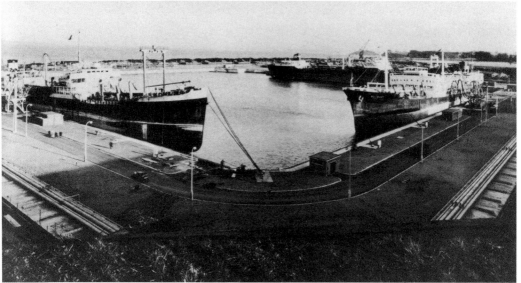

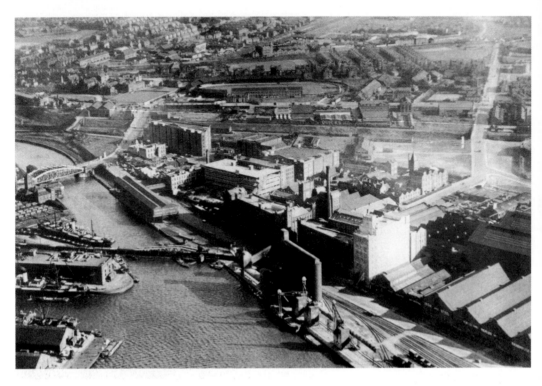

Trafford Wharf in 1936. At the bottom left of the photograph is Hall & Pickles, whose name runs along the gable ends of the factory buildings.

Trafford Wharf is on the left and Salford Docks are on the right.

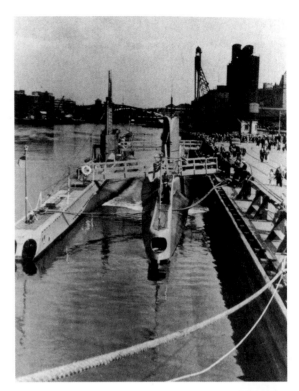

Right: A submarine at Trafford Wharf.

Below: Mode Wheel Locks from the west, with Trafford Park on the right of the photograph.

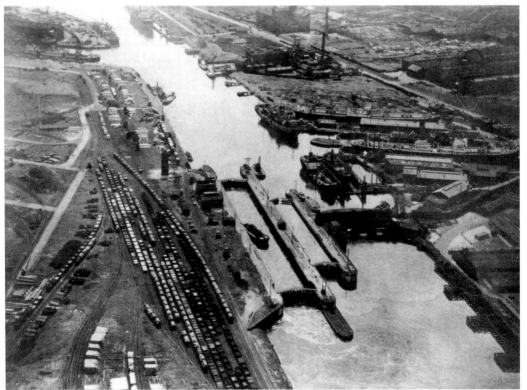

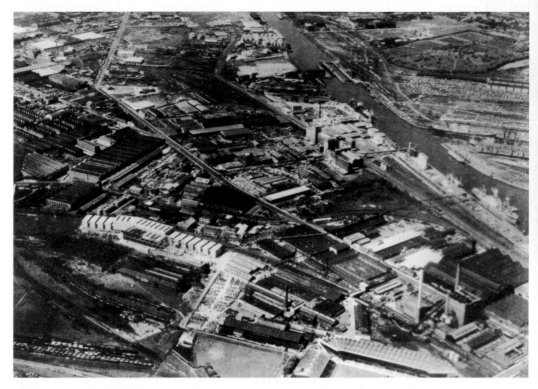

Above: Trafford Park and Manchester United football ground in 1969, with Mode Wheel Locks at the top left of the photograph. At the bottom left can be seen the Bridgewater Canal running past the curve of the football stadium.

Left: Unloading a ship at number nine dock on the Manchester Ship Canal in 1973.

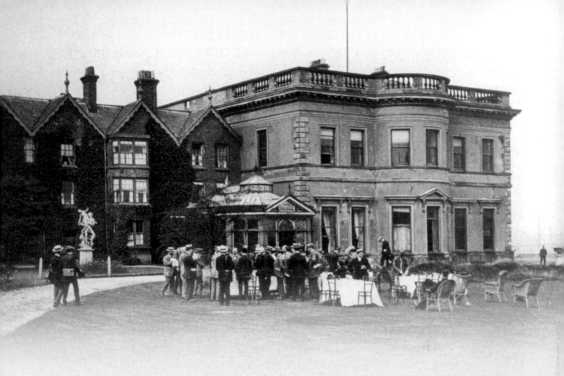

Chapter 2

Country Estate to Industrial Estate

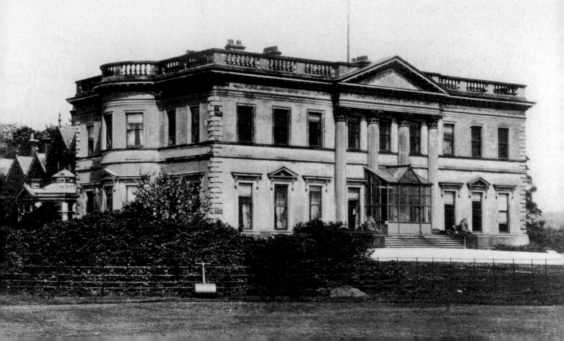

If you were to drive through Trafford Park today, you would find it hard to imagine that it was once a country estate and the former home of the ancient family of Trafford or de Trafford, as they were eventually to become known. The family home and once beautiful park stocked with deer are all long since gone, to be replaced today with what is left of an industrial city undergoing a further new regeneration.

The Trafford family can trace their lineage back to Norman times and possibly even further back to an earlier Saxon period around the time of King Canut, although the Trafford Park estate is not mentioned in the Domesday survey of 1086 (Robert Nicholls, Trafford Park: The First Hundred Years, 1996). During the thirteenth century, the two main landowners in the Stretford area were the Trafford family and the de Mascy family. An early surviving document from this period refers to Henry Trafford paying a rent of five shillings per year for land held in Stretford (1212). Sometime during the early part of the thirteenth century, Hamon de Mascy passed over his claim to the Stretford land, resulting in the lordship of Stretford (including that of Trafford) passing over to the Trafford family. The history of the Trafford family has already been well documented and as such, will not be covered in detail in this book.

The manor of Stretford was roughly divided into two by a large area of mossland and to the north was bordered by the River Irwell, which provided a natural defence against any possible threat of invasion. The Trafford family home was known as Trafford Hall and was situated in the north part of the manor. The estate included a medieval deer park, which was first documented in 1533 (Michael Nevell, The Archaeology of Trafford, 1997) but was thought to be much older.

One of the early references to a Trafford Hall on the estate was taken from an inventory in 1590 on the death of Sir Edmund Trafford, which stated that Trafford Hall had thirty-three rooms. This Trafford Hall was thought to have been built sometime during the sixteenth century and was described as a 'quaint black and white building' (Chetham Society New Series Volume 51). It stood at the junction of Chester Road and Talbot Road, roughly in the area where the White City Retail Park is today. It was at one time surrounded by a moat, and after the Trafford family vacated the property, it was often referred to as the moat house.

Around the year 1632, Cecil Trafford bought Whittleswick Hall, which was situated approximately two miles north-west of Trafford Hall, close to where Proctor & Gamble manufacturing plant is today, and this became known as the new Trafford Hall. The hearth tax for 1673 has two references to a dwelling called Trafford Hall, indicating that the two Trafford Halls were at this time both occupied by the Trafford family. The Trafford family took up residence at the new Whittleswick Hall sometime between 1673 and 1703, although the exact date is not known. The area where the old Trafford Hall was located was referred to as Old Trafford to distinguish it from the new Trafford Hall over at Whittleswick. The name Old Trafford is still in use today and covers that part of Stretford where the original hall and park once stood.

The Trafford Park estate included over 708 acres and measured over three and a half miles at its widest. For centuries, its unique position provided a secluded country estate for generations of the Trafford family; however, this was to change during the early part of the eighteenth century when the demands of an industrial age began to encroach on the estate.

The Industrial Revolution and the subsequent prosperity of the city of Manchester increased the need for improved transport links to the city. This included the navigation of the River Irwell, followed closely by the building of the Bridgewater Canal in 1759.

Canals were fast becoming a major transport link during the eighteenth century as the road system proved inadequate to cope with the demand from an ever-expanding industrial country. They allowed for quicker, cheaper and more reliable transportation across England. The Duke of Bridgewater originally wanted a canal which would link his coal mines in Worsley to Hollins Ferry on the Mersey and Irwell Navigation and then go on to Salford, but he decided to expand this plan to include Manchester following along another route. He undertook this project along with his agent John Gilbert and the civil engineer James Brindley. Brindley's innovative ideas allowed him to design a canal that would run along the contour lines keeping the canal as level as possible, which meant that, although not necessarily straight, the canal was always flat and therefore did not require many locks. Brindley's main achievement was the aqueduct at Barton, where the canal passed over the River Irwell. It has been described as one of the seven wonders of the canal age (Michael Nevell, The Archaeology of Trafford, 1997). Brindley faced a large amount of opposition over the construction of the aqueduct, but it proved to be a magnificent achievement allowing for boats with loads up to fifty tons to travel over it. The canal passed through the Trafford Park estate on the south-eastern and south-western edge, and the Trafford family must have been involved in negotiations with the Duke of Bridgewater for this route to be allowed. There appears to be no evidence that the family opposed the canal, and although many historians think that they probably did object, they may even have approved of the project, as the canal would have assisted with the drainage of Trafford Moss and allowed them to reclaim part of their land. The Ordnance Survey map of 1848 indicates the impact the Bridgewater Canal had on the Trafford estate as the Industrial Age progressed. The estate was fast becoming an island and the privacy it had enjoyed formerly was slipping away. This was to continue in a more dramatic way as the century drew to a close and the Manchester Ship Canal project was undertaken.

The idea for the Manchester Ship Canal was first discussed at a meeting of businessmen, which took place at the home of Daniel Adamson in 1882. This one meeting set in motion a series of events, which was eventually to transform a country estate into a worldwide industrial marketplace. Sir Humphrey Trafford, who was the owner during this period, saw the Manchester Ship Canal as a threat to his land and estate, and employed one of the best lawyers of the time, Sir Ralph Littler KC, to fight the proposal. Despite Sir Humphrey's continued opposition, the bill was finally passed through parliament after three attempts. However, Sir Humphrey did manage to secure some special conditions, one of which was the building of a steep slope topped by a wall, which would mark the boundary between the Trafford Park Estate and the Manchester Ship Canal Co., and would ensure some form of protection and privacy for the Trafford family. After his death in 1888, his son (also named Humphrey) took over the running of the Trafford estate, but he was more willing than his father to co-operate with the Manchester Ship Canal Co. and – possibly through financial pressure – was willing to dispose of large parts of the estate.

In 1889, an article in a local newspaper suggested that Sir Humphrey Trafford would possibly leave Trafford Park soon and put forward proposals for its possible use, including that of a public park. By 1893, the Manchester Corporation were considering purchasing the park and discussions began to take place, but these were eventually called to a halt when, in 1896, Sir Humphrey put the estate up for auction. The auction took place on Thursday 7 May 1896, and despite the earlier interest of Manchester Corporation they did not bid. Only two bids were received and the highest of these at £295,000 was not enough to secure the sale: the estate was withdrawn. Lengthy discussions with the Corporation continued, but there were repeated delays, as they could not agree on how to finance the project. On 23 June, the representatives from the Corporation were informed that Sir Humphrey had received an offer for the whole of the Trafford Park estate. The Corporation was still not able to make an immediate decision and so by noon the following day (24 June) the estate was sold for £360,000.

The purchaser was a man called Ernest Terah Hooley, who was a businessman and entrepreneur. In order to raise the extra cash to help finance the transaction, Hooley formed a new company, Trafford Park Estates Ltd. Marshall Stevens, who had previously been associated with the building of the Manchester Ship Canal, also joined the company and it was his driving force and determination that took the project forward. The new company was quick to exploit the potential of the whole of the Trafford Park estate and put forward the plan to open Trafford Hall as a hotel and golf course. The estate was opened to the general public, but this proved to be a very short-lived venture as there was soon evidence of damage to the estate and an attempted burglary on the empty hall. Despite this, the company continued with their plans and the lake was let out to a William Cooke & Sons to be used as a boating lake. The boating lake was a successful enterprise with boats available for hire at 2d or 6d per hour. Various other attempts were made to utilise parts of the large estate, including an area for shooting and for a military training ground. In May 1898, a large area was taken up when Manchester Golf Club took up residence. The golf club ran into problems when the Trafford Park Estates Company decided to furnish rooms in Trafford Hall for use as cheap catering facilities for visitors to the estate. The public proved to be a nuisance by wandering onto the golf course, disrupting play and causing a safety hazard. This problem was not alleviated until the golf club purchased a lease on the rooms to use them as clubrooms, thus eliminating the problem.

The Trafford Park Estates Company was keen to move ahead with the industrial development of the park and by March 1897 one of the first companies, the Manchester Patent Fuel company, was set up on a site close to the Bridgewater Canal at Barton. The birth of the industrial Trafford Park had begun.

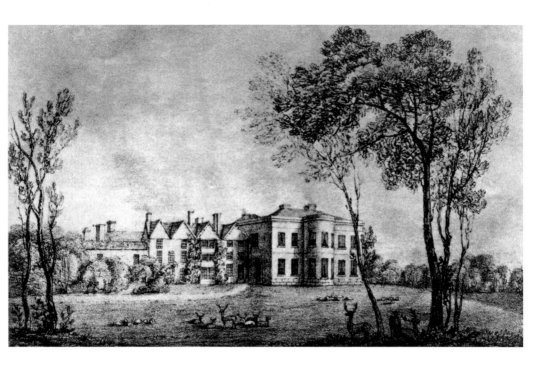

Trafford Hall and deer park in the early nineteenth century.

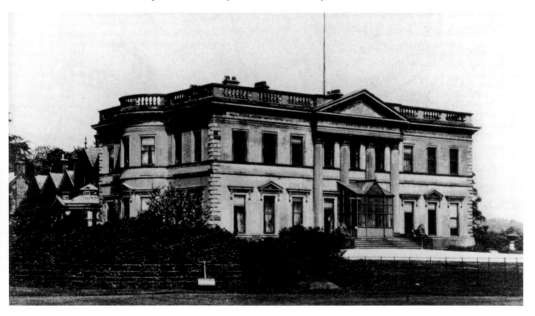

Trafford Hall in all its glory. The older part of the hall, which is thought to be that of Whittleswick Hall, can be seen on the left of the photograph behind the conservatory.

Overleaf: The full extent of the Trafford Park Estate can be seen here on the Ordnance Survey map of 1848. The estate boasted an icehouse where ice would be produced for the estate kitchen.

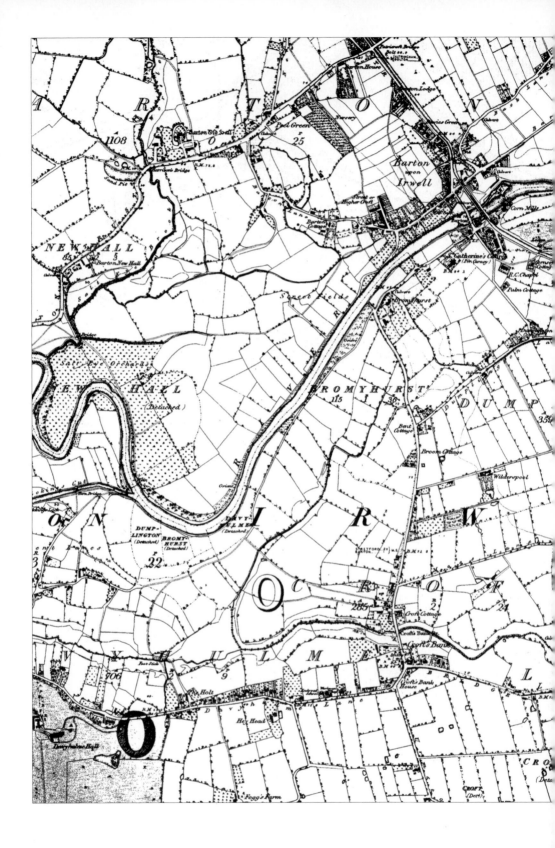

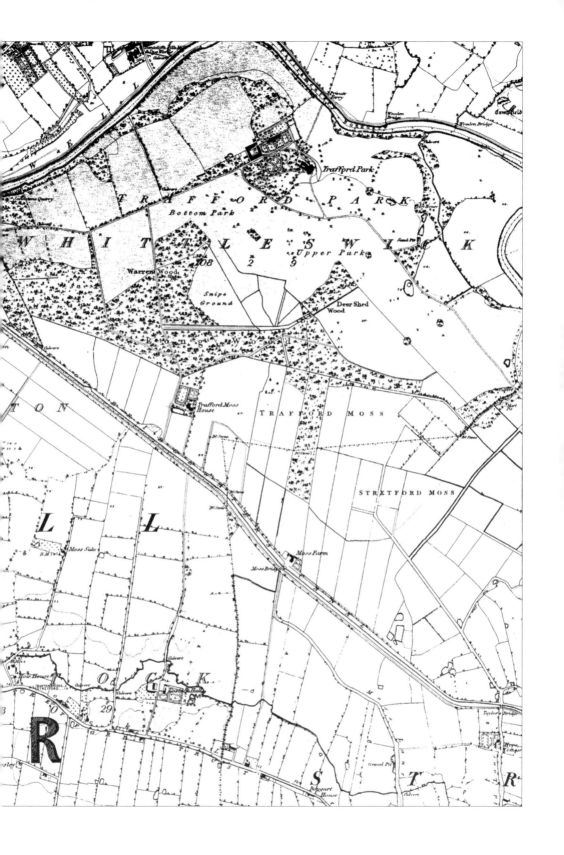

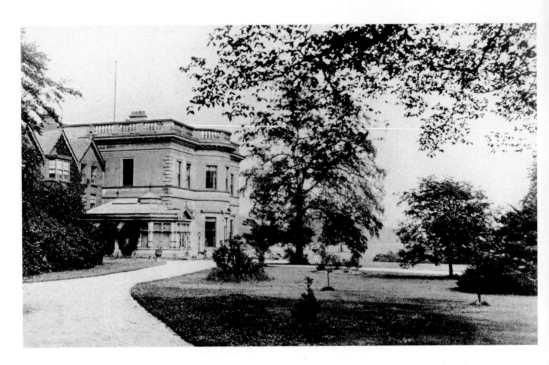

This view of Trafford Hall shows the older part more clearly and the two contrasting building styles are visibly evident.

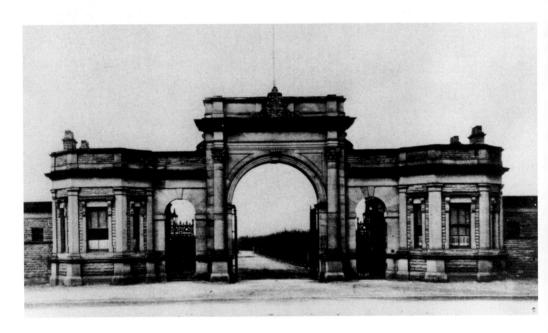

The gates and lodges to Trafford Park are seen here in their original position on Chester Road, Stretford, and provided a grand entrance to the estate. They stood opposite the entrance to the botanical garden, where the White City retail park is now (2003). They were later moved to stand at the entrance of Gorse Hill Park Stretford, where they can still be seen today.

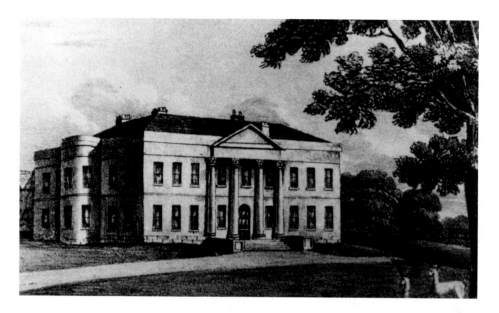

Trafford Hall taken from an engraving. The estate was famous for its deer park, which was thought to date back to the medieval period. However, as the Trafford Park estate developed, the roaming deer became a safety hazard and were culled.

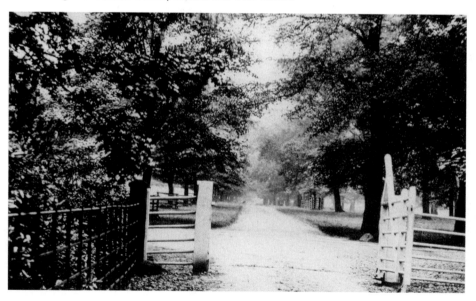

In 1888, a group of visitors to the estate described their arrival: 'Entering the Old Trafford entrance, there is a direct rural walk of four miles before the Barton gate is reached. Some fine old hawthorns, which stand by the carriage drive, have suffered from the Manchester smoke, and many of the fine trunked oaks show painful signs of air poison in their upper branches. At the west end of the park, there is some fine timber, such as oaks, elms, Spanish chestnuts and beech trees. A great acquisition to the landscape is an avenue of sycamores and limes, planted about a century ago.' (Transactions of the Lancashire and Cheshire Antiquarian Society, 1888). This photograph of one of the entrances was taken around 1896 and reflects this rural description.

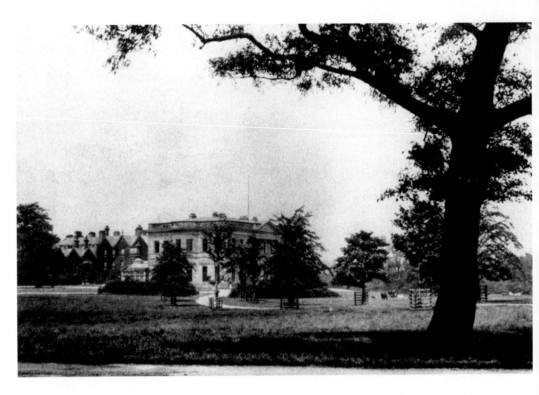

Trafford Hall around 1896.

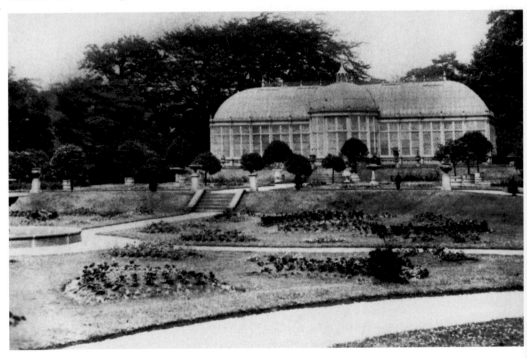

The gardens and conservatory of Trafford Hall.

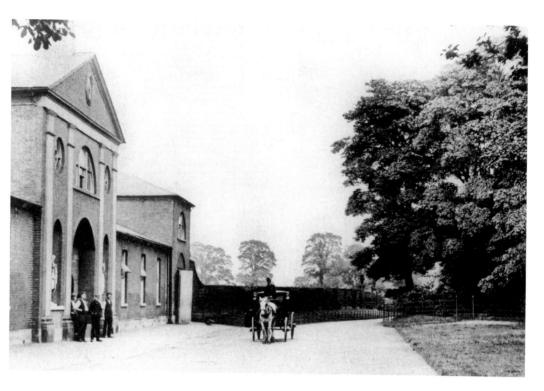

One of the entrances to the Trafford estate, *c.* 1896.

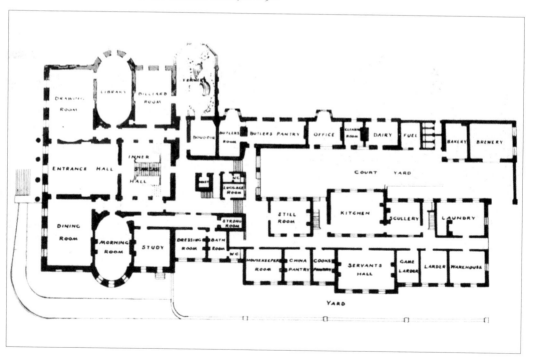

Ground floor layout of Trafford Hall.

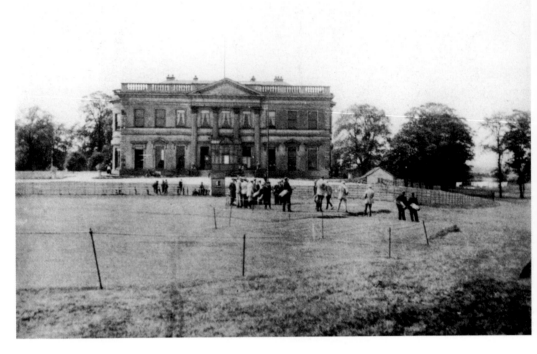

Trafford Hall, seen here when it was the home of the Manchester Golf Club. (Courtesy Mr H. Steer).

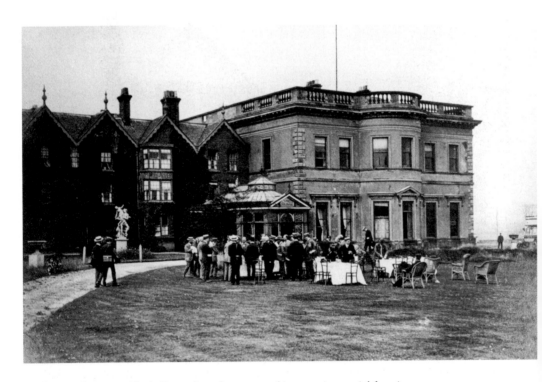

Trafford Hall in 1905. The ladies and gentlemen are taking part in a social function.

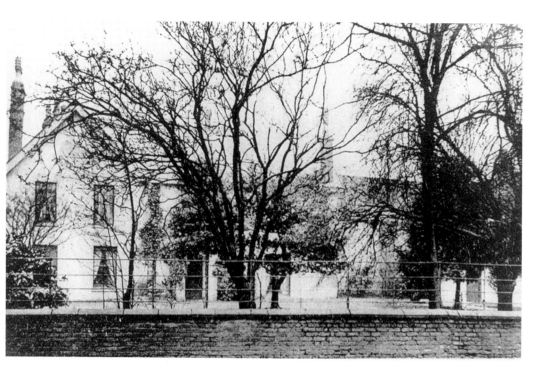

Trafford Old Hall.

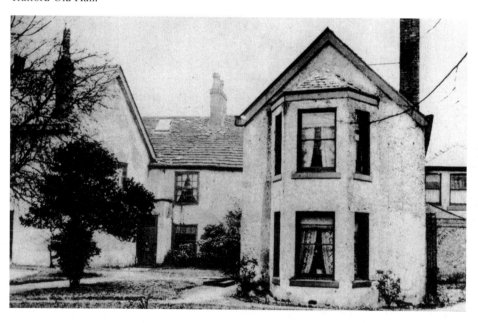

After the Trafford family vacated the hall, it was eventually converted into three separate residences. The number 587 can be seen on the door to the right of the photograph. In its glory days, Trafford Old Hall was surrounded by a moat (which was still evident in 1857) and it was at one time known as the Moat House or the Moat. It was said to have secret passages, which linked it to Ordsall Hall in Salford and Whittleswick Hall.

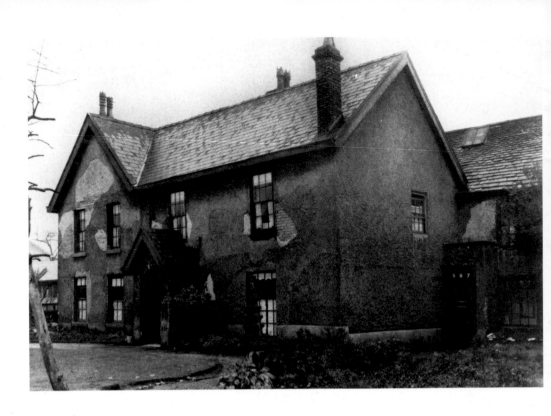

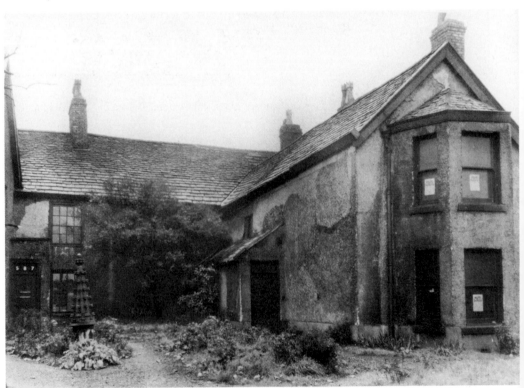

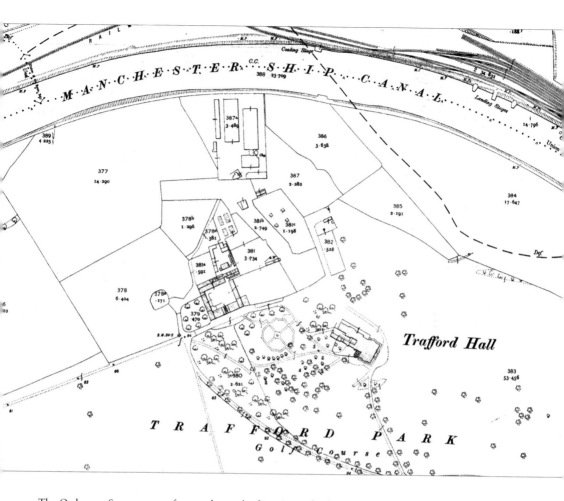

The Ordnance Survey map of 1913 shows the first signs of industry encroaching on the Hall from the banks of the Manchester Ship Canal.

Opposite above: This photograph was taken around 1937, after the house was left empty.

Opposite below: Another view of the abandoned Trafford Old Hall. Vandals were a constant problem, and signs warning against wilful damage can be seen displayed in the windows. In 1939, Stretford Council demolished Trafford Old Hall as part of a corporation clearance scheme.

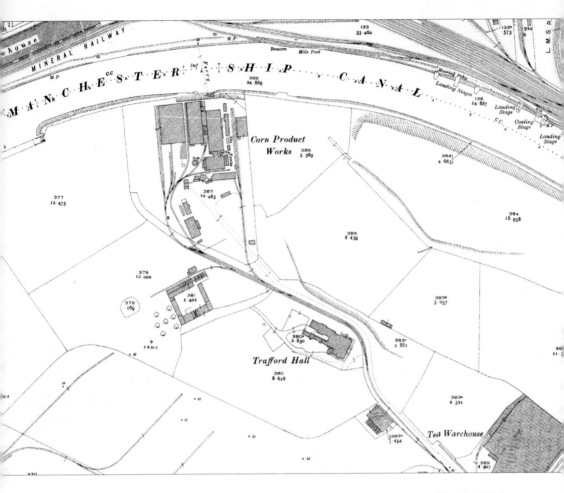

The Ordnance Survey map of 1929 gives a clear picture of the increasing isolation of Trafford Hall.

This Ordnance Survey map of 1937 clearly indicates how both Trafford Hall and Lake were becoming increasingly isolated as they were surrounded by industry.

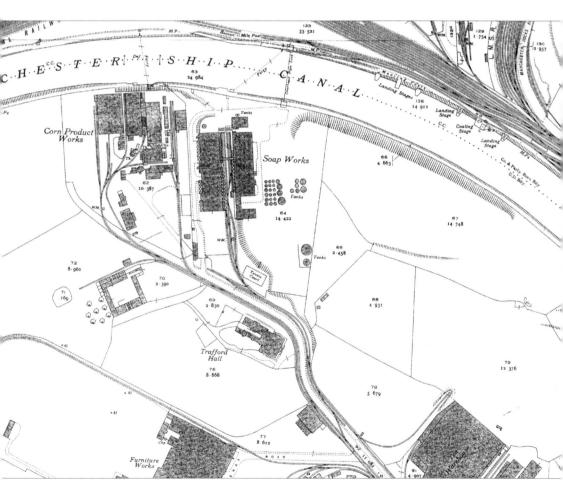

This photograph, taken in 1951, shows the site of the gates to Trafford Hall after they had been removed to Gorse Hill Park.

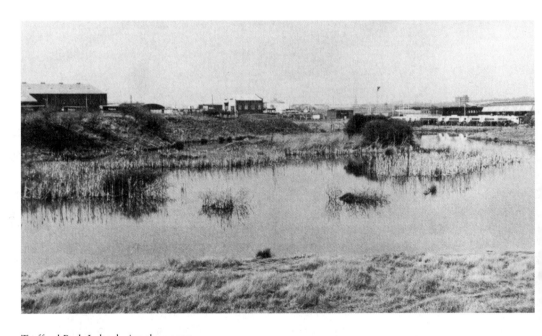

Trafford Park Lake during the 1970s.

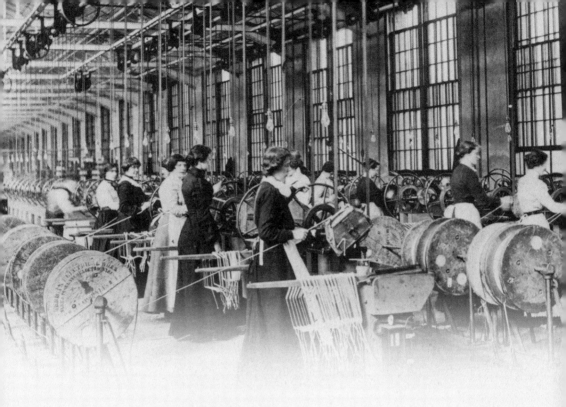

Chapter 3
Industries

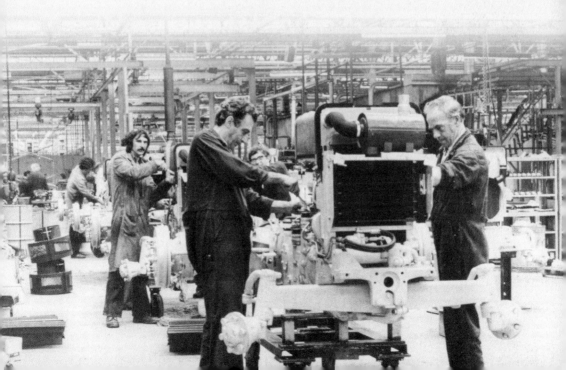

Initially, development of the estate was slow to take off, but by 1900 Trafford Park as an industrial area was beginning to take shape, with many new companies taking up the challenge. This had a knock-on effect on services, and created a demand for roads and associated infrastructure for the ever-expanding workforce. The landscape began to take on a more industrial appearance, as factories and roads started to swallow up the open spaces, and large areas were developed as housing to accommodate the needs of the workforce.

Trafford Hall became increasingly isolated as the development of the estate occurred around it. The deer, which had for centuries been allowed to roam freely, were becoming a nuisance, so by 1900 they had all been culled. In 1912, Trafford Hall faced an uncertain future when the Manchester Golf Club decided to move out to new premises after their lease expired. During the First World War, the then owners of Trafford Hall, the Guinness family, placed the Hall at the disposal of the Red Cross for the establishment of a military hospital. They also provided around £3,000 towards the running costs, with the money for the equipment provided by the Trafford Park Estate company. There were 105 beds in 13 wards and, by 1915, the hospital had admitted 613 British soldiers, 27 Australians, 10 Canadians and 6 Belgians, with the average admittance running at 77 per month.

The initial development of Trafford Park, which took place between 1900 and 1920, saw many big-name companies establishing themselves, some of which are still familiar to us today. These included: Trafford Brick company; Morrison Ingram & Co. (sanitary engineers); Bennet's Sawmills; Nuttall's; Manchester & Liverpool Transport Co.; J.W. Southern (timber merchants); J.D. Sandar & Co. (maltsters); James Gresham (engineers); W.T. Glover & Co. (cable manufacturing); Morrell Mills (engineers); Kilverts (edible fats); R. Baxendale & Co. (millers); Liverpool Warehousing Co.; Lancashire Dynamo & Crypto Ltd; Bagnall Oil Co.; British Westinghouse; Cooperative Wholesale Society; Ford Motor company; and Hovis Ltd.

Much of this early industrial development had established itself in the eastern part of the Park; the arrival of British Westinghouse between 1899 and 1902 saw the start of development in the south. British Westinghouse and the Ford Motor company were American companies, and both brought with them new working practices that were different from those already established in Britain. Assembly lines meant that work could be carried out more effectively, but the repetitive nature of the work was very hard on the workforce, with continuous production and long hours allowing little or no time for breaks. In an article by Ian McIntosh (published in 1995), entitled 'It was worse than Alcatraz', he quotes from workers of the old Ford factory, both men and women, who described the harsh conditions they had to endure. However, this did not deter people from working there and there was no shortage of labour, as the wider negative economic climate during this period meant that there was always an abundance of people who were on the lookout for regular work.

As more and more large engineering companies set up business in Trafford Park, the area began to assume a strategic importance within the country as a whole. This was tested to the limit during both world wars, with the country struggling to maintain a balance between production and supply. Many companies were affected when workers took up service in the armed forces, but at the same time the overall employment level actually increased, as some occupations were protected and the demand for production was never-ending. Many women joined the labour market and Metro-Vickers employed over 3,500. Some companies transferred over to the production of wartime materials, including Metro-Vickers (who

produced armaments), Taylor Brothers (gun bearings), Glovers (the manufacturer of Bailey Bridges), and Turners (who made army huts and munitions). The Ford Company returned to a section of their old site at Trafford Park to take up production of the Rolls Royce Merlin engine.

There was a fighting spirit amongst the workforce of the Park, and many people remember that period being one of great friendship and possessing a sense of purpose. Even Trafford Hall, which had been empty for some time, was used as a billet for the Royal Engineers, who used the lake for military training purposes.

As the war went on, Trafford Park became a strategic target and was bombed heavily, the worst attacks being in December 1940 during the Manchester Blitz. Metro-Vickers was extensively damaged, as were many other factories and warehouses, including the Hovis Mill and Trafford Hall. Despite this, Trafford Park survived and reconstruction was carried out continuously.

By the 1960s, the success of Trafford Park had peaked, and by the late 1960s and early '70s, the country as a whole was suffering economic decline. Many companies were forced into reducing workforce levels in order to survive, and strikes and industrial disputes became commonplace. During this period, many companies started to disappear, as takeovers and closures became more and more frequent. Those to go included Kilverts, Lancashire Dynamo, Edward Wood & Co. (steel producers). As companies started to close, there was a knock-on effect on the environment as premises were left empty. Efforts were made to improve the landscape and, in 1970, the Trafford Park Industrial Council was created to try and halt the decline of Trafford Park. One of the first incentives it brought about was to award a green pennant to any company that improved its surroundings.

British Westinghouse

George Westinghouse, a successful American businessman, had been looking for a possible site in England for some time. He wanted to build an electrical manufacturing company in England, which would be on a grand scale. The Trafford Park site held many advantages for this: there was easy access by road, water and rail, as well as an abundance of coalfields close by to provide fuel. The Park was situated so close to the densely populated areas of Manchester and Salford that there would always be a ready supply of people on the lookout for work. In a letter confirming the sale (dated 10 July 1899), George Westinghouse acquired 130 acres of land situated in the area around Waters Meeting Farm, close to the Bridgewater Canal. Work began on the Westinghouse Company almost immediately and was completed in less than eighteen months.

Its unique construction was documented stage by stage in a series of photographs (some of which are included in this book), and the building materials included more than 11 million bricks and 9 million feet of timber. The Westinghouse factory covered over thirty acres and the machine shop was at one time one of the largest in the world. In 1909, George Westinghouse cut his ties with the company, although the firm was to remain under American control for some time. Throughout the intervening years, constant changes in the structure of the company through takeover bids saw the company name change many times, but the more familiar names to most people will be that of Metropolitan-Vickers Electrical Co. Ltd

(1919) or Associated Electrical Industries (AEI). When AEI took over in 1928, the company continued to trade under the name of Metropolitan-Vickers (Metro-Vicks for short) for many years. In 1967, the company was finally taken over by GEC.

Thousands of workers have passed through the gates of the Metropolitan-Vickers factory since it was first built, and for many years it was the largest employer in Trafford Park. During the war years, the company suffered extensive damage from bombing during the Manchester Blitz, but remained productive. Many people who live in the north-west of England (and even further afield) will know someone or perhaps have a relative who worked at 'Metro-Vicks'. Since its inception in 1896, the history of the site has always been synonymous with that of Trafford Park.

Ford

The Ford plant at Trafford Park was the first outside America and brought with it new ideas of production to Britain. The Ford Company believed that the northern working classes would provide the ideal workforce for their company. The assembly plant worked on a conveyor-belt system, which was first introduced in 1914. The workers stood in a pit assembling the parts as the chassis were moved along. This allowed for continuous production and the company was able to produce up to sixty cars per day. At first the company imported parts from America, which was cheaper, but eventually they were constructed in the UK. During the First World War, Ford produced service vehicles and casings for ammunition. The 1920s brought a period of expansion as the company achieved peak production and, in 1925, Ford reached a milestone when it produced its 250,000th car. Unfortunately, this rapid expansion in the market was also to be the downfall of the Trafford Park site, as competition from other companies (such as Austin and Morris) created the need for a larger manufacturing site, which the Trafford Park could not accommodate. In 1926, Ford bought the Dagenham site in Essex and, by 1931, the plant and machinery, along with 1,000 men were transferred.

CPC

Nicholls, Nagle Ltd was a small corn milling and glucose refinery that had been struggling to survive in Trafford Park since 1911. In 1922, they were bought out by CPC, who went on to improve and modernise the refinery. During the 1950s, the company changed its name to Brown & Polson Ltd – a name with which many people are more familiar. Expansion in the 1950s allowed the company to build a 700ft wharf on the Manchester Ship Canal to allow seagoing ships to offload their cargoes of corn directly into the company's silos. The company changed its name during the 1990s to Cerestar.

Kellogg's

In the period prior to the Second World War, the Kellogg's company were keen to build a factory in England, as they were concerned that trade with Canada would be affected if war broke out in Europe. A factory in the UK would ensure that the company's interests would be maintained. The Trafford Park site would mean that the company had a central

base in England and was close to major transport links with the rest of the country. The proximity of the Bridgewater Canal allowed grain to be brought by horse-drawn barge from the Manchester Ship Canal to the docking basin, and was so successful that it remained continuous until 1974. On 24 June 1937, the Mayor of Stretford poured the first concrete onto the Trafford Park site and the factory was completed in less than ten months. All the buildings were numbered in the American system, with number one being the workmen's lavatory and number two the canteen. The company provided a staff canteen and was keen to encourage good health amongst its employees. The first medical officer was Dr Whiteside, who practised in Davyhulme. Since 1938, when the first packets of cornflakes were produced at the Trafford Park site, the company has expanded its range and today is one of the most successful cereal manufacturers in the UK.

Imperial Chemical Industries Ltd (ICI)

Imperial Chemical Industries Ltd (ICI) was situated on Westinghouse Road on the former site of the British Alizarine company. During the Second World War, ICI produced penicillin in what was the first plant in the United Kingdom. They also produced monastral blue for map production and other synthetic dyestuffs. The site was home to two branches of the large ICI Company, each producing a different range of products. The Organics Division was situated on one side of the site (producing dyestuffs), with the Pharmaceuticals Division on the other (producing unrefined drugs for the pharmaceutical market). The pharmaceutical site was home to a large fermentation plant, where the raw drugs were produced. A series of laboratories on the site ensured quality control of the product, which would then be transferred to the ICI site at Alderley Edge in Cheshire for refining and packaging. The company included a share bonus scheme for employees and had its own canteen, as well as a medical centre which employed both a doctor and a nurse. The company moved out of the site during the 1980s.

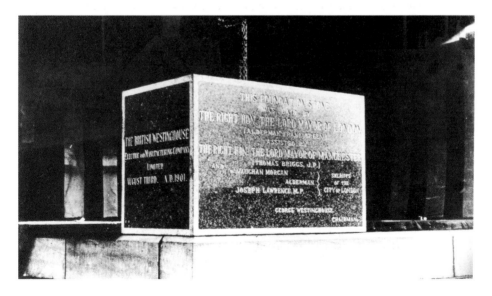

The foundation stone of British Westinghouse, dated 3 August 1901.

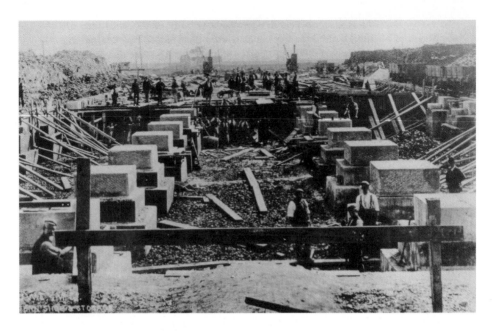

Workers constructing the pattern shop at British Westinghouse in 1901.

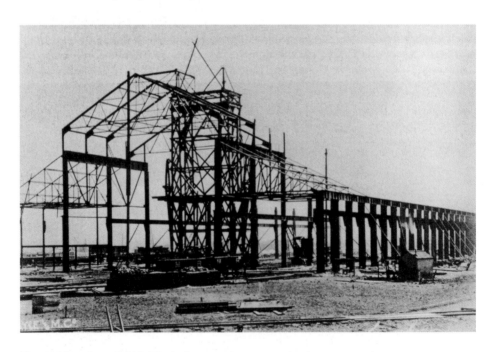

The steel foundry at British Westinghouse under construction in 1901.

Opposite page: These photographs show British Westinghouse factory and buildings in various stages of construction in 1901. *Above and middle:* The machine shop and offices.
Below: The outfall sewer.

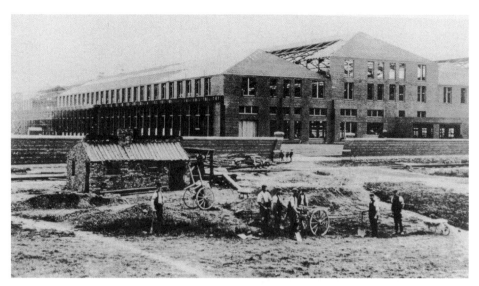

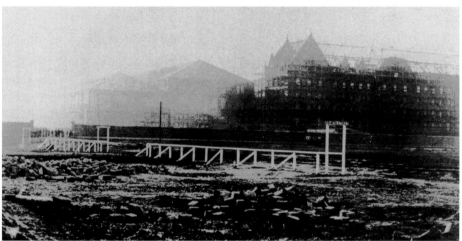

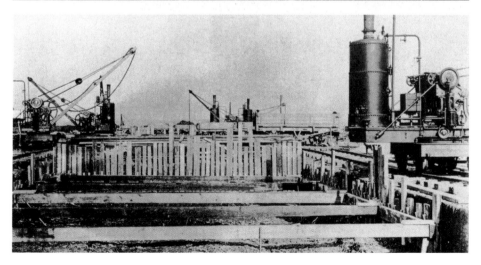

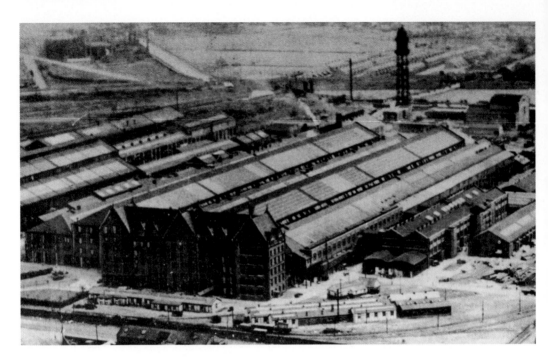

This aerial photograph was taken from an air balloon in 1902, and shows the British Westinghouse factory almost completed.

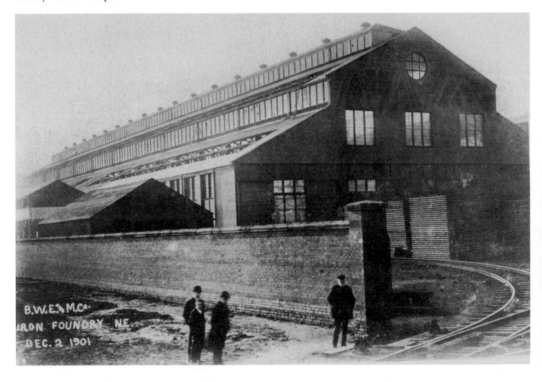

The iron foundry at British Westinghouse, 1901.

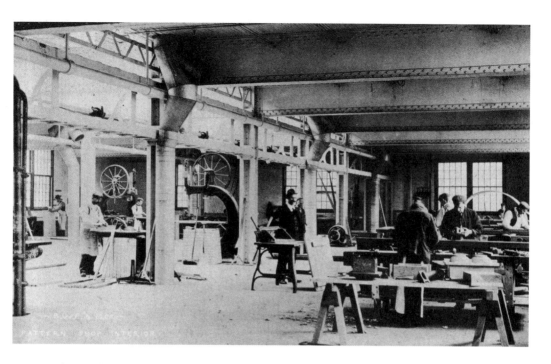

Workers at the pattern shop, British Westinghouse, 7 May 1902.

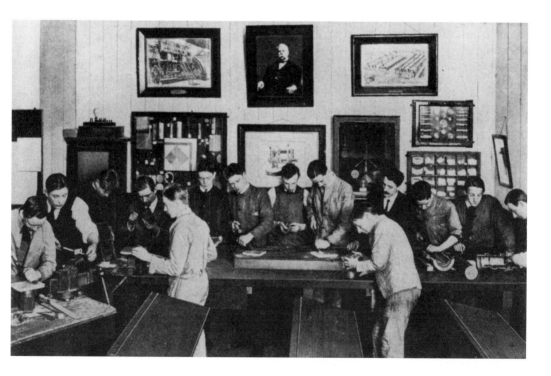

The first apprentices' training school at British Westinghouse in 1902. A photograph of George Westinghouse is on the wall.

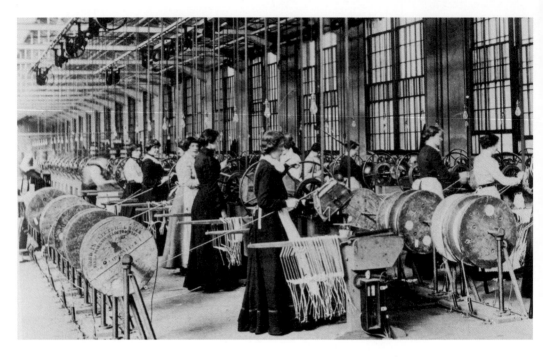

Both men and women were employed at British Westinghouse. This photograph shows women at work in 1906.

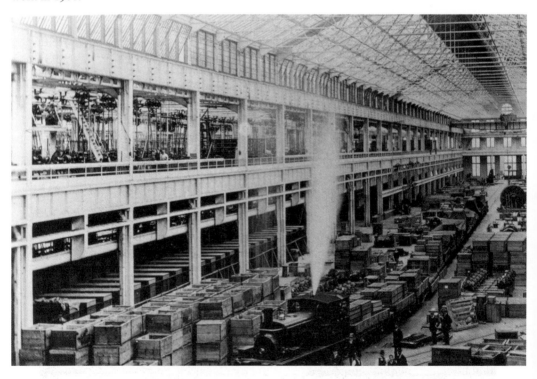

Aisle D, British Westinghouse in 1902; the tools arrive from Manchester by rail link.

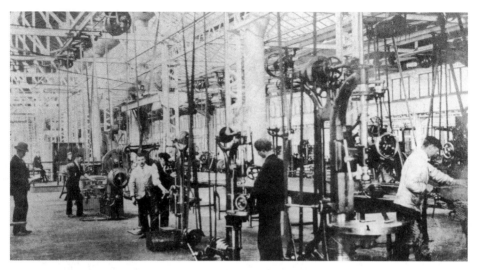

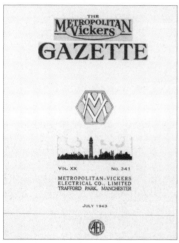

Above: The machine shop and gallery at the Westinghouse works.

Left: The front cover of the Metropolitan-Vickers Gazette, a magazine produced by the company for its employees; this edition is from July 1943.

Below: Mr Roy Hoyle and Mr Fred Waddington in the pattern shop at Associated Electrical Industries Ltd (AEI) during the late 1950s.

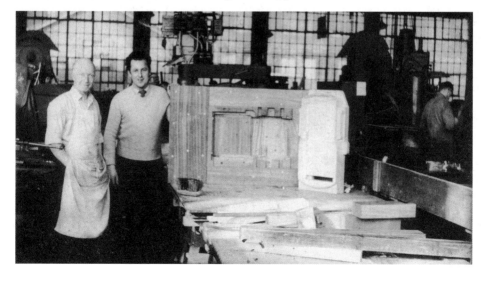

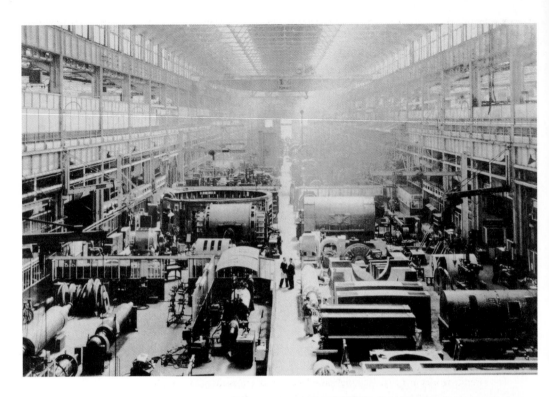

Above: Aisle D at AEI in 1964. Compare with the photograph of D aisle from 1902, when the firm was known as British Westinghouse.

Right: By 1973, the company was trading as GEC, and in this photograph we see Christopher Chataway (Minister for Industrial Development) being shown the turbine blades by Mr G. Trowbridge (Works Manager).

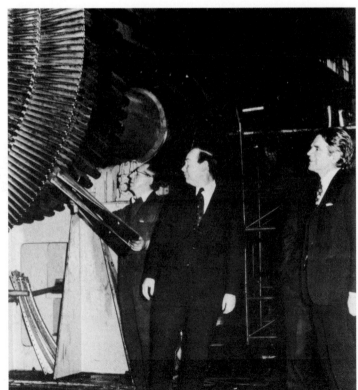

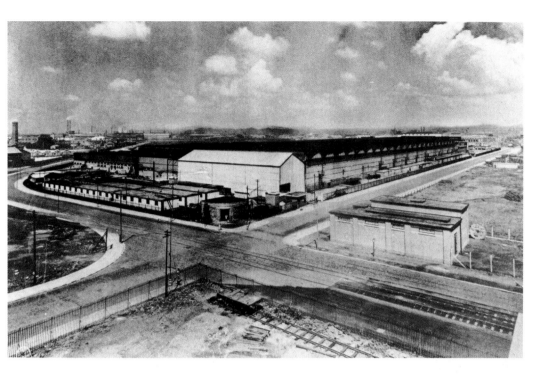

The aircraft works in 1973; Westinghouse Road runs across the photograph.

This photograph of GEC was taken in the 1970s. (Courtesy of Sefton Samuels FRPS, ref.3-42-3).

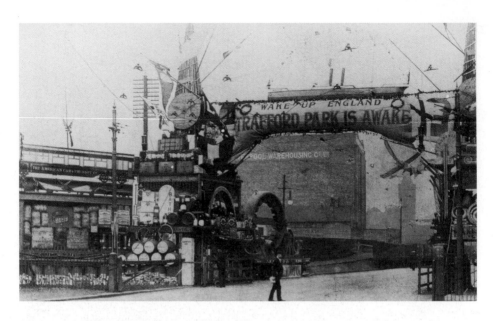

Above: In July 1905, King Edward VII and Queen Alexandra visited the Manchester and Salford area to open the new dock of the Manchester Ship Canal. The Royal procession was celebrated throughout the district, with trophies and flags marking the route. Arches of flowers were positioned at strategic points, depicting the transition of the area from a rural district to a more industrial one. The main feature was a triumphal arch on the Trafford Road entrance to Trafford Park. It was built with raw materials manufactured by the firms in Trafford Park and depicted the motto 'Wake Up, England! Trafford Park is awake'.

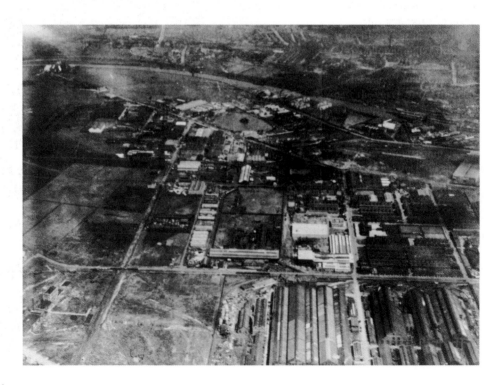

Above: Millington and Sheldrake (gummed paper and tape manufacturers) Elevator Road, 1973.

Right: The slitting room at Millington and Sheldrake, where rolls were divided into coils.

Opposite below: Aerial view of Trafford Park, 1928.

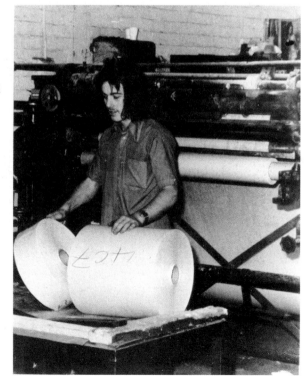

Stacking the rolls of paper at the Millington and Sheldrake factory, watched by then company director Mr F. Booth in 1973. The company partnership was originally formed in 1879.

The tube department at the Millington and Sheldrake (gummed paper and tape manufacturers) in March 1973. This photograph shows the strawboard tubes used in the textile and polythene manufacture being cut, glued and rolled.

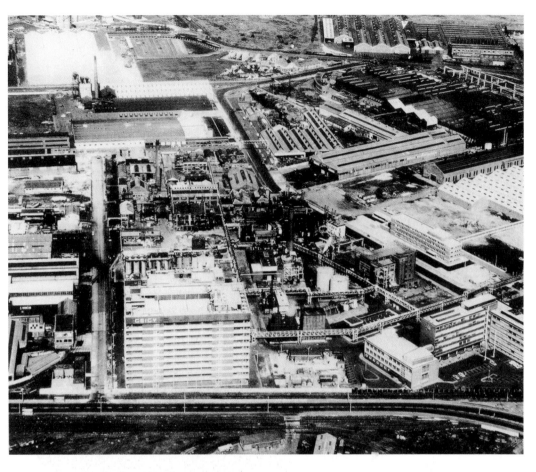

An aerial view of the Ciba-Geigy Chemical Company, 1969.

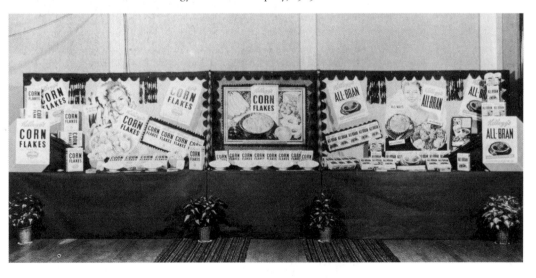

The Kellogg's display at the 'Stretford Can Make It' exhibition in 1949.

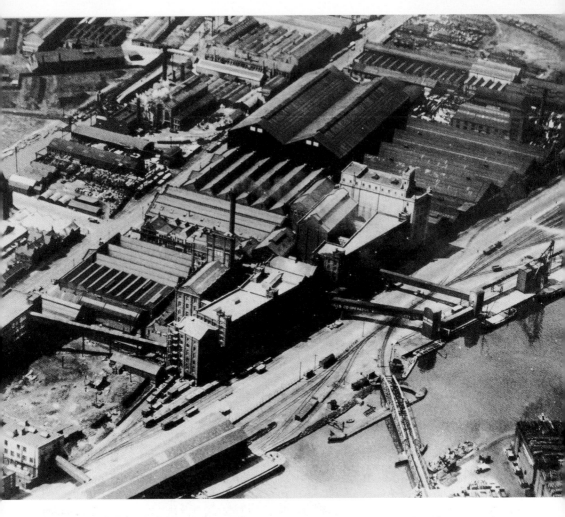

An aerial view of the CWS Flour Mill and Wharf, taken in 1929. The wharf allowed for grain to be transferred to the mill directly from the docks.

Above: Workers at the Redpath
Browns factory in 1925. The man in
the centre is C.J. McCormick, who
was later to become a professional
footballer for Manchester United and
Fulham.

Right: Trafford Carpets in 1973. The
four-yard wide loom could produce a
carpet in seven hours.

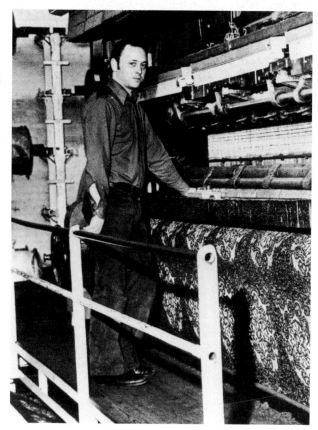

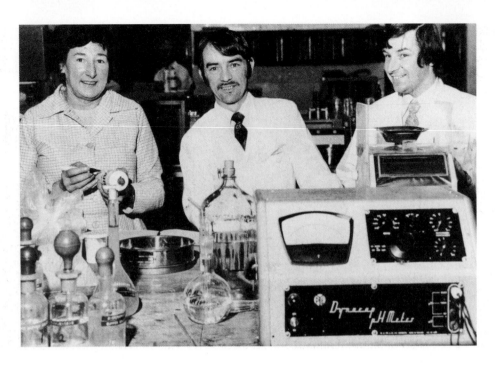

Workers in the quality control laboratory at Proctor & Gamble (soap manufacturers) in 1973.

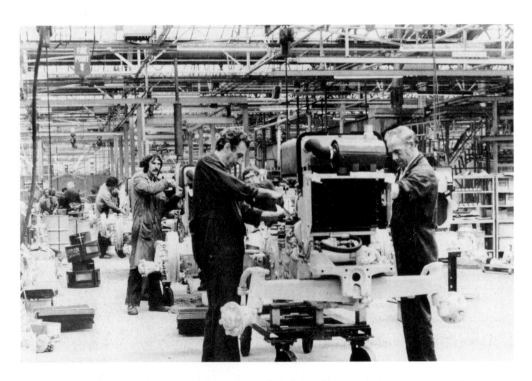

Massey-Ferguson were situated on Barton Dock Road, and this photograph shows men at work on the factory floor in the late 1960s.

The Massey-Ferguson factory during the 1970s. (Courtesy of Sefton Samuels FRPS, ref. 3-43-36).

Turners Asbestos Cement were producing asbestos cement as far back as 1914, and following the end of the First World War, the demand for construction materials allowed the company to expand rapidly. This photograph of the company offices was taken in 1973.

Turners Asbestos during the 1970s. (Courtesy of Sefton Samuels FRPS, ref. 3-15-12).

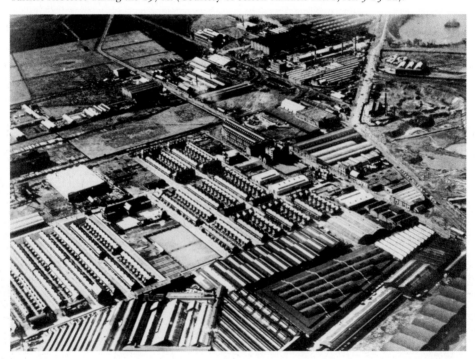

The Ford Motor company established itself in Britain in 1911. Motor vehicle parts were imported from America to build Ford cars for the British market. In 1931, the company moved out of Trafford Park to a new site at Dagenham. This aerial photograph was taken in 1925 and shows how the layout of the company was constructed in the American style.

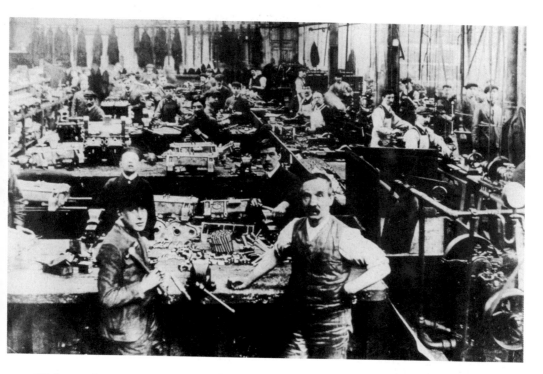

Workers at the Ford Motor company during the early 1900s.

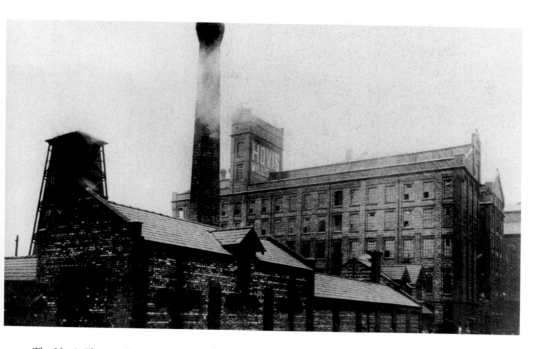

The Hovis Flour Mill was built in 1905. The grain was transferred from ships on the Manchester Ship Canal to the mill by means of a grain elevator and an underground wharf, which in turn was linked to the mill by a conveyor belt.

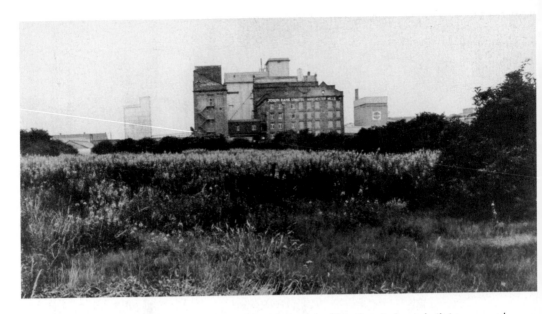

The Joseph Rank Flour Mill, formerly owned by Joseph Greenwood & Sons Ltd, was built in 1909 and was linked to the Manchester Ship Canal in the same way as the Hovis Mill.

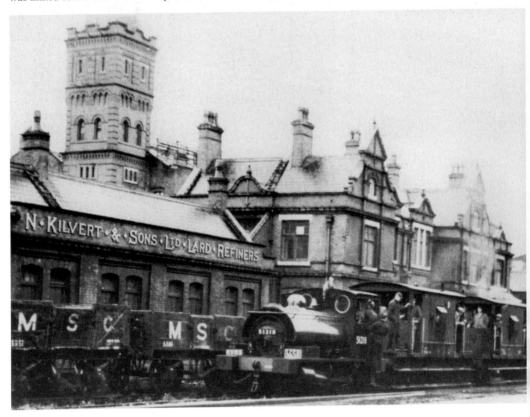

N. Kilvert & Sons (lard refiners).

The Brooke Bond factory. This 1973 photograph shows the wooden tea chests in the warehouse.

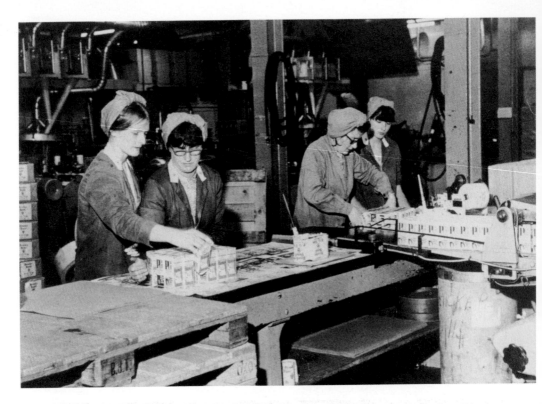

This photograph of the Brooke Bond factory during the 1960s and '70s shows the tea packaged in the boxes with which many people will be familiar.

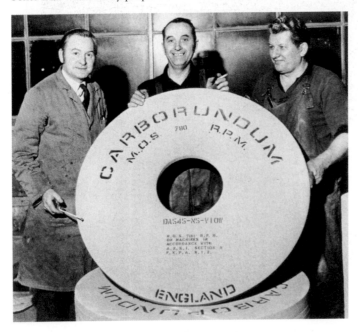

Workers at the Carborundum factory in 1973.

An aerial photograph of the J.W. Baldwin factory, 1973. It produced a type of wood wool but, in 1964, the factory suffered a serious fire and had to be rebuilt.

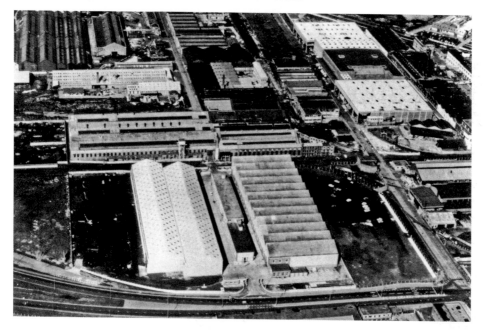

A general view of Trafford Park taken in 1969.

Overleaf: An aerial view of the Parkways roundabout taken in 1968. On the bottom left of the photograph can be seen the laboratories of the ICI Pharmaceuticals plant, with Ciba-Geigy top left.

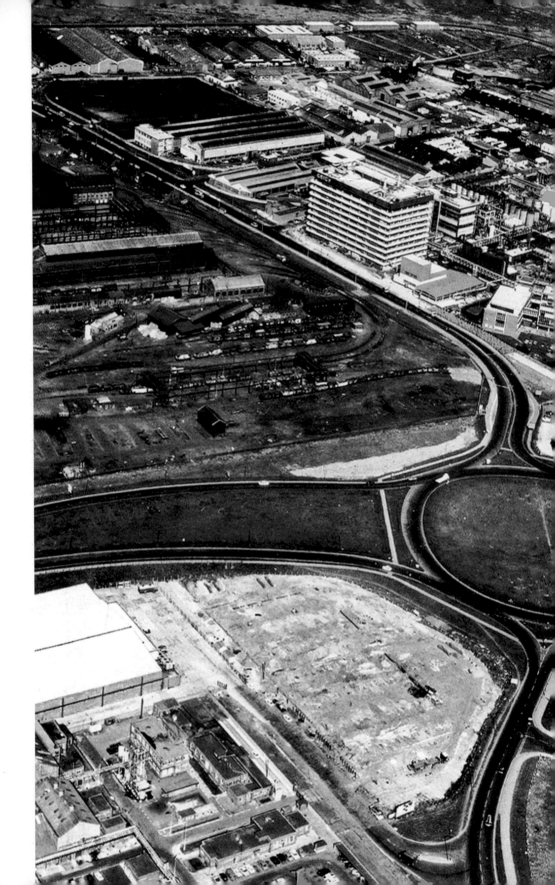

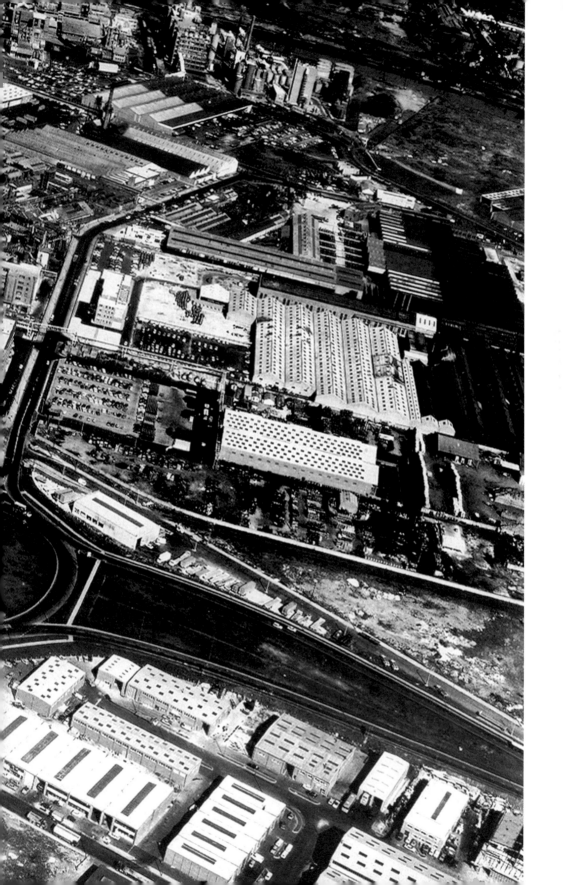

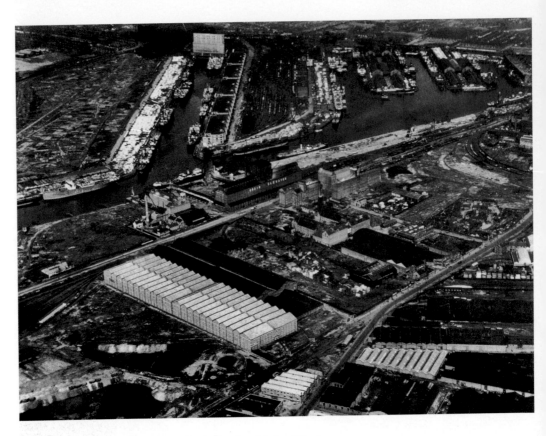

Trafford Park in 1925, showing Trafford Wharf and Salford Docks.

Opposite above: This photograph of Ciba-Geigy was taken during the 1970s. (Courtesy of Sefton Samuels FRPS, ref. 3-16-36).

Opposite below: Deliveries at the CPC factory in the 1970s. (Courtesy of Sefton Samuels FRPS, ref. 3-16-36).

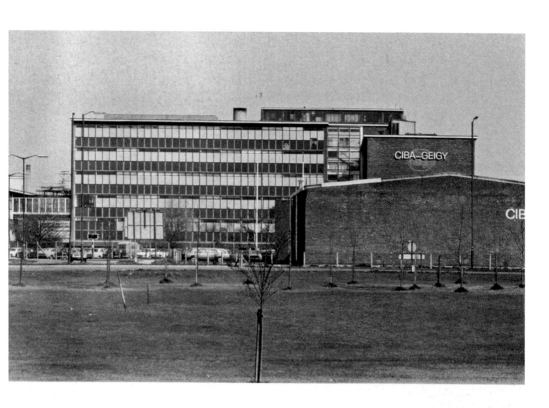

73

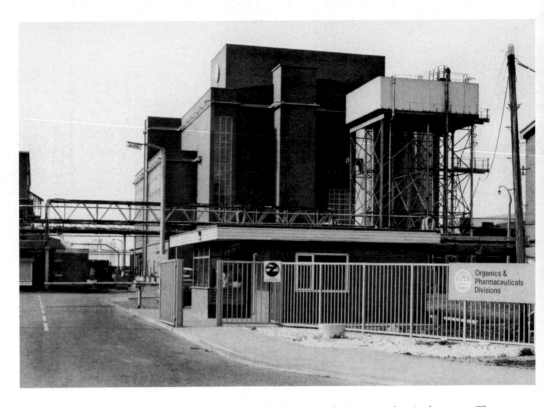

This photograph of the entrance to Imperial Chemical Industries Ltd (ICI) was taken in the 1970s. The site was home to two separate divisions of ICI – the Organics Division and Pharmaceuticals Division. (Courtesy of Sefton Samuels FRPS, ref. 3-42-11).

Chapter 4
Servicing
the Park

In an advertising publication of the 1930s or 1940s, designed to attract more businesses to Trafford Park, the criteria for establishing a successful factory were listed under the following considerations: the cost of inward and outward transport; a reliable supply of electricity, gas and water; and the availability of an adequate labour force. The booklet then went on to explain that Trafford Park could satisfy all these criteria.

The attraction of industry was essential for the survival of the Ship Canal, which was not an overnight success. In fact, it struggled for the first few years of its existence, despite the formation in 1898 of Manchester Liners Ltd, which purchased two ships and planned to build four more. The Bridgewater was not totally eclipsed by the Ship Canal and, because of its connection to the South Lancashire Collieries, it was always important for the transport of coal – by the 1930s, it was carrying in excess of 300,000 tons annually. The Bridgewater was described as one of the main assets of Trafford Park, and was still viable for the transport of goods 'not susceptible to deterioration' or where time of delivery and collection was not an overriding factor.

The arrival and dispersal of raw materials and finished products via the Bridgewater or the Ship Canal was only the first part of the factory operation. The commodities had to be transported in two directions; the raw materials had to be taken from the canals to the factory gates for making up, and the finished products had to be taken from the factories to the canals for distribution. For the most part, this two-way traffic was achieved via the internal railways in Trafford Park. This system provided connections to all the main railway lines and to Manchester Docks, and the advertising literature for Trafford Park in the 1930s and 1940s never failed to point out that the traffic along its internal railways amounted to just over three per cent of the railway traffic of the entire country.

The building of the Trafford Park railways were authorised by specific acts of parliament, and there was a resident engineer in overall charge. Factory owners were allowed to build their own sidings with the advice of the engineer, but without the usual protracted negotiations and paperwork that would have applied elsewhere in the country. The firms had to pay for the lines near to their factories and the junction with the Trafford Park railway system, but the savings in transport by lorry would soon override the outlay.

The internal railway was one of the most important features of Trafford Park. It is in evidence everywhere on the old photographs of various factories and streets in the Park, and many of the lines are still in situ today.

The production of electricity was well under way before the turn of the century. In October 1898, Trafford Park Estates Ltd granted to William Paul James Fawcus the exclusive rights to supply electricity to all the establishments in the Park, including the lighting of the roads and streets. This arrangement lasted for just a few months, until in April 1899, William Fawcus transferred his rights and privileges to the Trafford Power & Light Supply Ltd. The first generator was placed in the premises of W.T. Glover & Co Ltd, and from this factory, overhead lines connected the generator to the switchgear and boiler house of Trafford power station. Consumers of electricity in 1900 included W.T. Glover, British Westinghouse Co. Ltd, Illingworth Ingham (Manchester) Ltd, N. Kilvert & Sons Ltd, Lancashire Dynamo Co. Ltd, Royce Ltd, Sandars (Maltsters) Ltd, and Trafford Park Dwellings Ltd. The power station was situated near the junction of Warwick Road North and Trafford Park Road. The necessary fuel was brought by barge on the Bridgewater Canal, and to a lesser extent by rail. The electricity

power station underwent several reformations. After the First World War, The power station was taken over by Stretford Urban and District Electricity Board. In 1935, it was closed down, and the bulk supply of electricity was purchased from the Central Electricity Board. However, a few years later, starting in 1939, the Trafford Power Station was rebuilt, with another reconstruction in 1947. The following year brought nationalisation, by which time the power station was serving perhaps the greatest and largest industrial estate in Europe, consuming 4,000 tons of coal every week, brought by barges of fifty to sixty tons in capacity. The works straddled the Bridgewater Canal, with the main works including the control room, the boiler house and turbine house on the north bank, and the coaling plant and the coal stockpile on the south bank. One of the unique features of the power station was its delivery system, whereby the coal was drawn up from the barges by means of a suction plant, the first one being installed in 1925. When the power station was rebuilt, it was decided to build another, larger suction plant, which could keep the 1,000-ton bunkers supplied at a rate of ninety tons per hour.

Of equal importance was the supply of gas. In the 1930s, the Stretford and District Gas Board delivered gas from their works adjacent to Trafford Park. Towards the end of the 1940s, however, the supply was taken over by the North Western Gas Board (Stretford) Undertaking. The water supply was another vital consideration for anyone setting up a factory in the Park, and the advertising brochures never failed to mention it. Some of the water was obtained from artesian wells sunk into the red sandstone underlying the Park. Around fifteen firms availed themselves of this type of water supply – notably the glucose works of Corn Products Co. Ltd, whose artesian well boasted a capacity of 50,000 gallons per hour. Westinghouse built its own water tower, which became one of the most famous landmarks in the Park. The tower was over 200ft high, and was built in 1902. The water was pumped to the top of the tower to be used to work the hydraulic system for the lifts and sprinklers in the factory. Many firms needed water for cooling purposes, and both the Ship Canal and the Bridgewater Canal provided water to satisfy these needs. The rest of the water supply was provided by the Manchester Corporation, from its reservoir at Grasmere in the Lake District. This water was proudly advertised by the Corporation because it was 'of excellent quality, of striking softness, and so can be used for the raising of steam without any preliminary treatment'.

The labour force for the factories of Trafford Park was drawn from a wide area. In the 1920s, Manchester was situated almost exactly in the centre of one of the most densely populated areas in the world. Estimates from the 1921 Census show that there were over 10 million people within a fifty-mile radius of Trafford Park. Vast numbers of men and women were employed in the Park. By the end of the 1930s, there were 150 factories employing 40,000 people – Metropolitan-Vickers swallowed up about a quarter of this total. By the end of the Second World War, there were 50,000 employees – a figure that will probably never be exceeded.

In order to bring this workforce to the Park, there were trams, horse buses, railways and finally motor buses. Trafford Park Tramways originally brought people to the Park for pleasure outings – for instance to the Agricultural Show in the Park in 1897. The first trams were powered by gas (from the Stretford town supply), but there was a dispute between the British Gas Traction Co. and Trafford Park Estates, which rumbled on through 1897 and 1898. In 1899, it was decided to change to electric-powered trams, running on electricity provided by the Trafford Electric Supply Company. At this time, the most frequent journeys were to the

lake and to the stately home, since there were few factories. When the industrialisation began in earnest, for a short time horse buses brought workmen from Pendleton to the Trafford Road entrance. Then, in 1902, Trafford Park Estates established its own electric tram system, but because there was initially a dispute with Stretford town about the junction with their tram system, passengers coming from Manchester or Salford had to change trams at the swing bridge and the Park gates. This silly situation lasted until 1905, when the Salford and Manchester Corporations joined forces to set up a combined service. They took over the Trafford Park tram routes to create through-routing for the whole tram service. Motor buses became more common from the 1940s onwards and bus services were still in use during the 1960s. A survey conducted in 1962 showed that nearly 300 buses left the Park each evening at the rush hour – perhaps a modern version of the congestion can be seen today as cars try to get into and out of the Trafford Centre.

Though the trams and buses were of paramount importance in delivering workmen to the factories and taking them home again, it must not be forgotten that for many of the workers in the Park, travel to and from the factories was a matter of shoe leather and the ubiquitous bicycle, but these forms of transport tend not to have been photographed so frequently as the trams and buses.

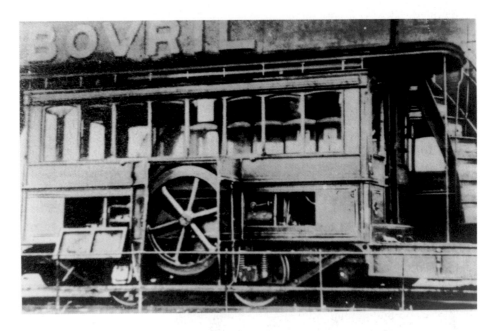

Above: A gas-driven tram as used in Trafford Park at the end of the nineteenth century.

Opposite above: Transport of goods into and out of the Park was one of the most important features that owners of factories would look for. This photograph shows a saddle-tank engine pulling goods wagons across the swing bridge connecting Trafford Park with Salford Docks.
Opposite middle: Internal Trafford Park railway lines running alongside Ashburton Road and the works of British Steel.
Opposite below: Springfield warehousing on Trafford Park Road and the internal railway lines running close by.

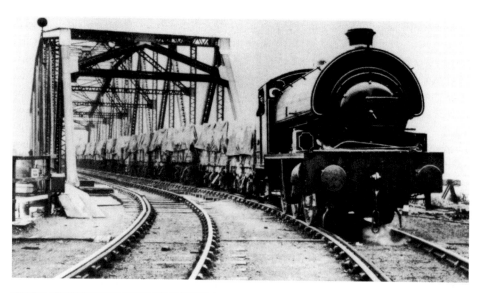

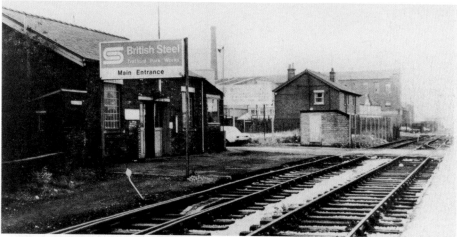

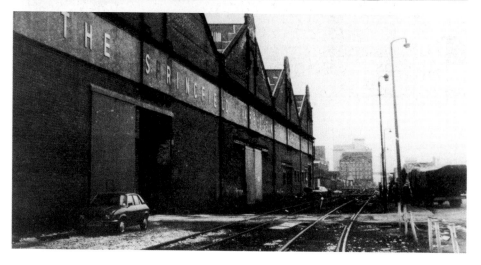

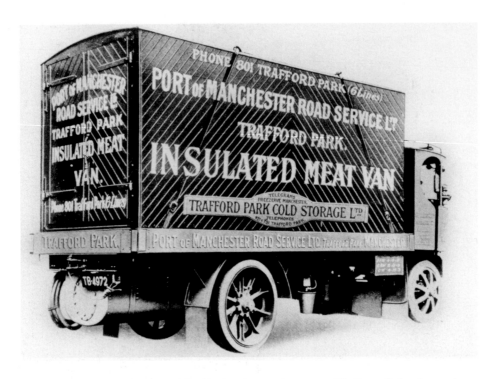

Storage and preservation went hand in hand with ease of transport. The Port of Manchester also operated its own road transport services, and this is one of their fleet of insulated vans from the 1920s.

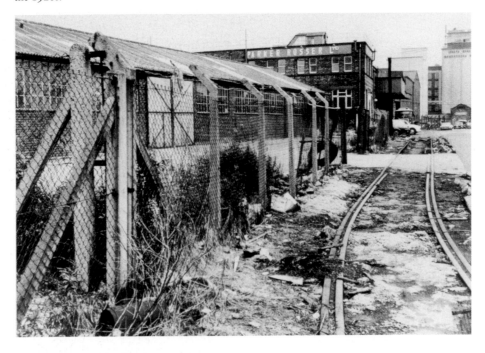

Abandoned railway lines on Elevator Road, 1974.

Right: Another view along Elevator Road, near Parker Rosser's offices showing damaged kerbs and the disused railway lines.

Below: Rail tracks being removed from Trafford Park Road in 1964.

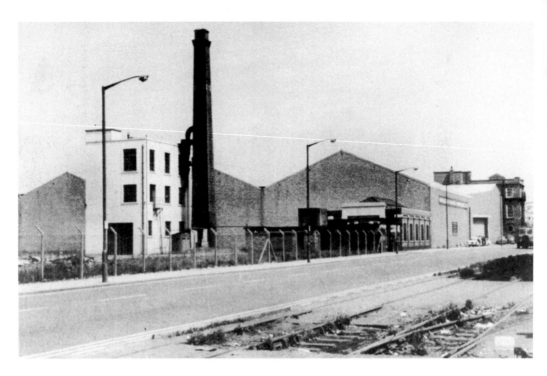

Trafford Park Road in 1966.

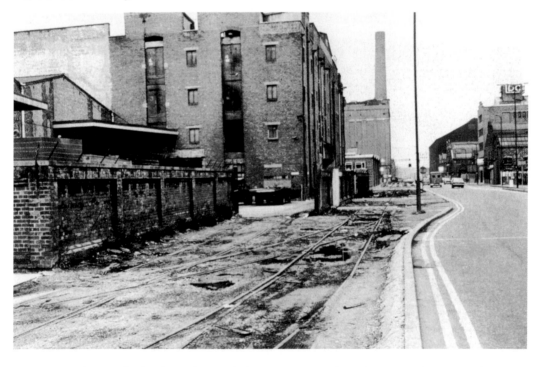

Looking west along Trafford Park Road, towards the power station whose chimney can be seen. On the right is Lancashire Dynamo & Crypto Ltd, with the initials LDC proudly displayed on the roof.

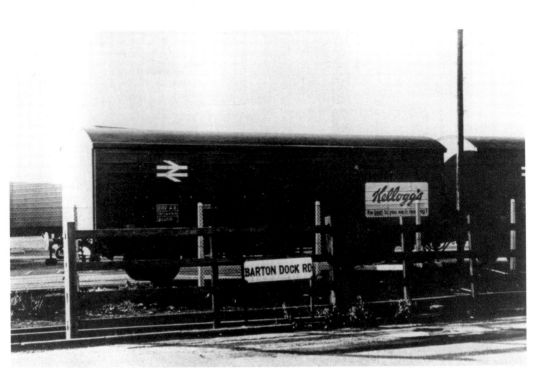

Kellogg's railway wagon on Barton Dock Road, *c* 1970.

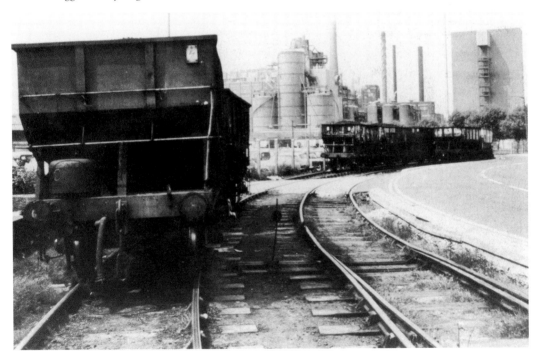

In 1974, when several railway lines had been abandoned, these lines at the western end of Trafford Park Road were still in use.

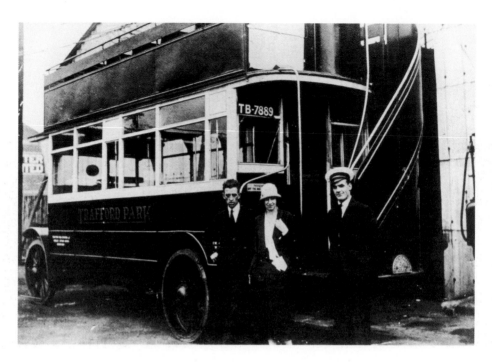

This is one of three open-topped, solid-tyred buses that operated in the early 1920s from Third Avenue to Patricroft Bridge. This photograph was taken at the Mosley Road garage, and the names written on the back are Alfred George (driver), Stanley Griffiths (foreman) and Mrs Griffiths.

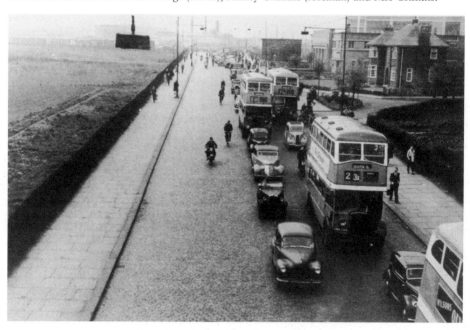

Queues on Park Road near the fire station, in 1957. Car buffs ought to be able to put a name to all the cars – is it a Ford Popular or a Ford Prefect pictured on the inside lane behind the second bus?

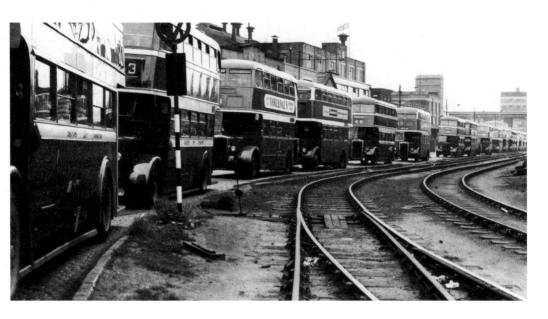

Buses waiting to turn into Trafford Park Road in 1963.

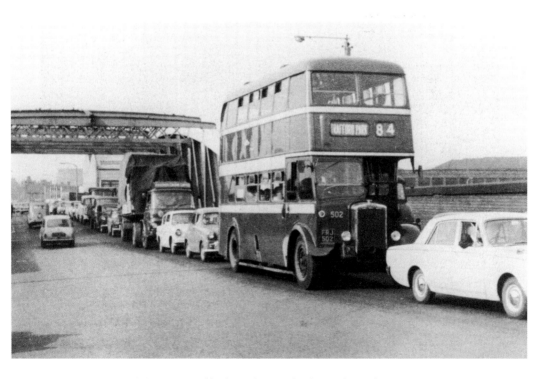

More queues at rush hour on Trafford Road swing bridge in the mid-1960s.

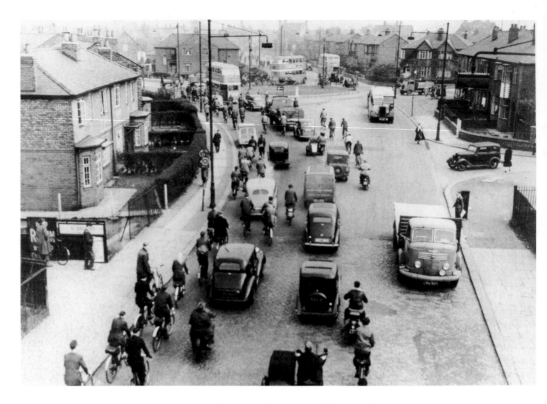

Five Ways roundabout in 1957 – proof that lots of people cycled to and from work.

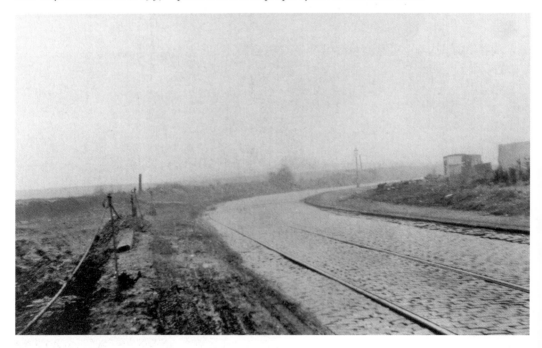

A foggy day on Ashburton Road.

Above: The old square 'setts' of Trafford Park Road, with a blurred horse and cart in the distance.

Right: Another view of Trafford Park Road with handcart.

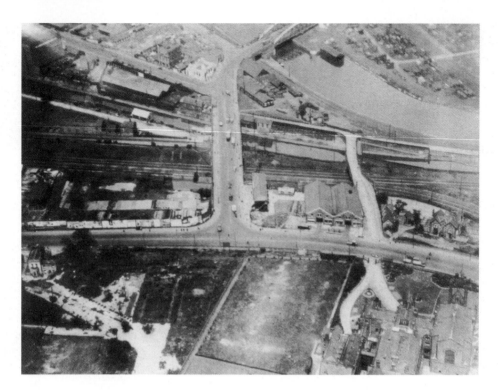

Trafford Road crossing the Bridgewater Canal and the Manchester Ship Canal, 1928. The swing bridge is just visible at the top of the photograph.

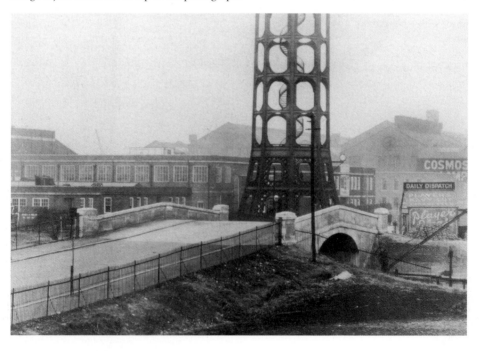

Moss Road bridge, built between 1937 and 1939, and the base of the Westinghouse water tower.

Car transport was in increasing use from the 1950s onwards. These cars are parked on Elevator Road in the early 1970s.

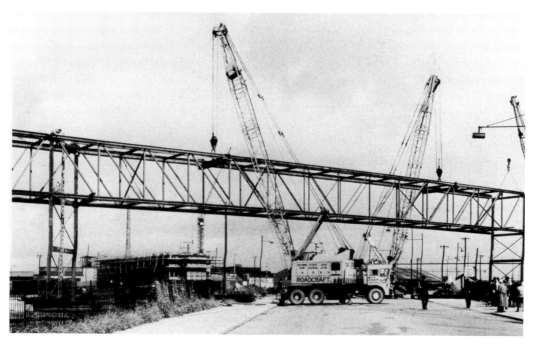

Kellogg's Bridge being constructed on Park Road, August 1963.

Barton Dock Road in 1965.

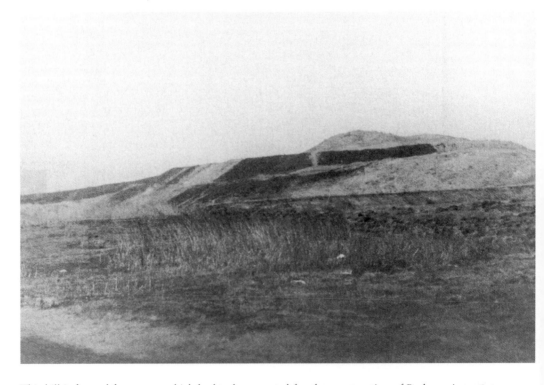

This hill is formed from peat, which had to be removed for the construction of Parkway in 1965.

Parkway in 1970.

Barton Dock Road with Parkway carried across it on a bridge.

Preparing to build Ashburton roundabout in 1967.

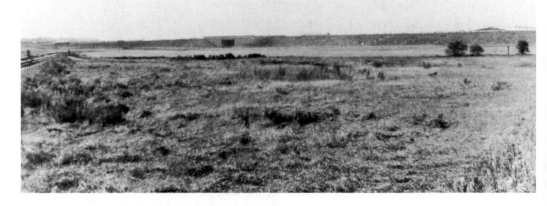

The proposed site for the development of a lorry park, off Barton Dock Road.

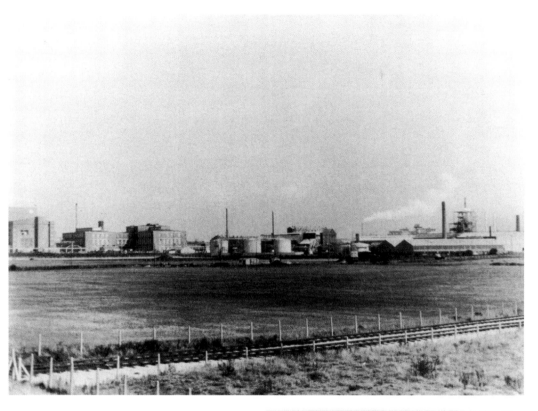

Above: Another view of the proposed lorry park.

Right: The pump house and power station at British Westinghouse, February 1902.

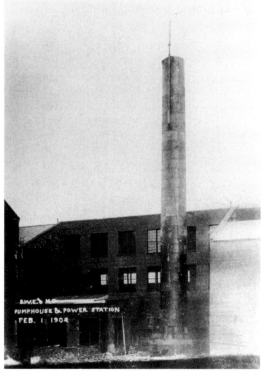

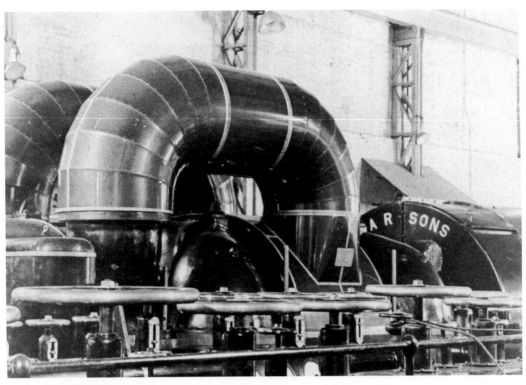

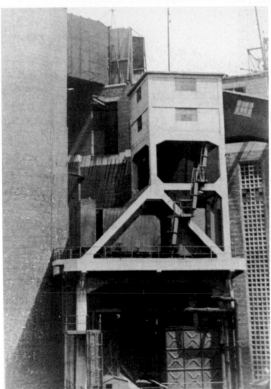

Above: Inside Trafford Park power station in 1947.

Left: The coal conveyor head at Trafford Park power station.

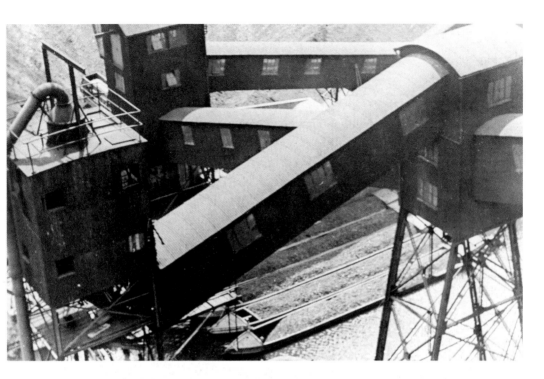

The coal conveyor at Trafford Park power station.

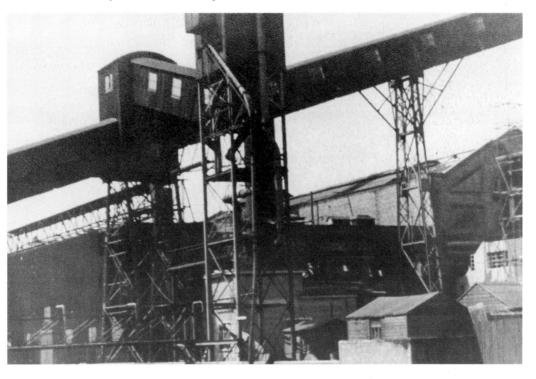

A ground view of the coal conveyor.

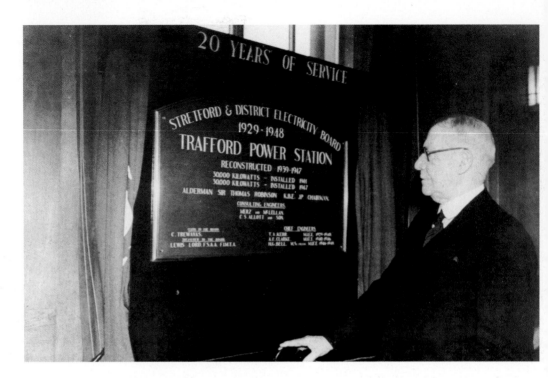

Reopening Trafford Park power station in 1948.

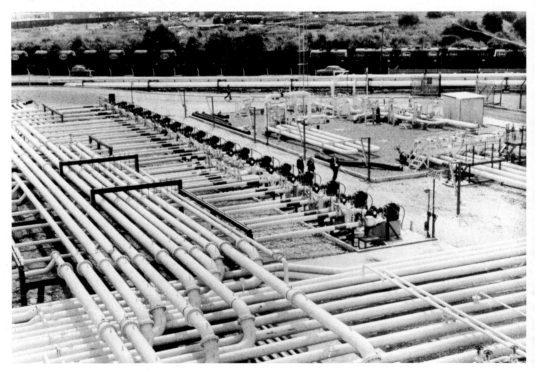

Pipework connecting the refinery to the storage tanks at the Esso oil terminal at Trafford Park.

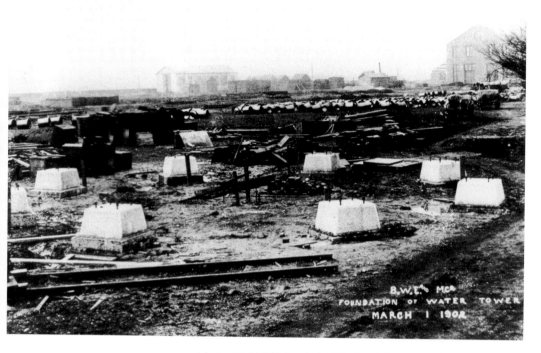

B.W.E's M^c
FOUNDATION OF WATER TOWER
MARCH 1 1902

Above: Foundations for the
Westinghouse water tower,
March 1902.

Right: The water tower under
construction in April 1902.

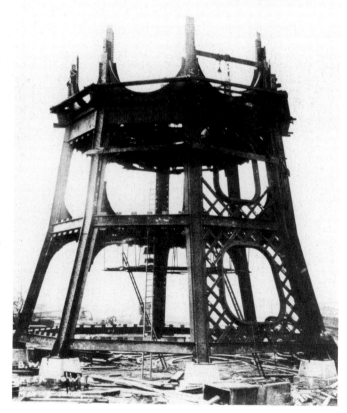

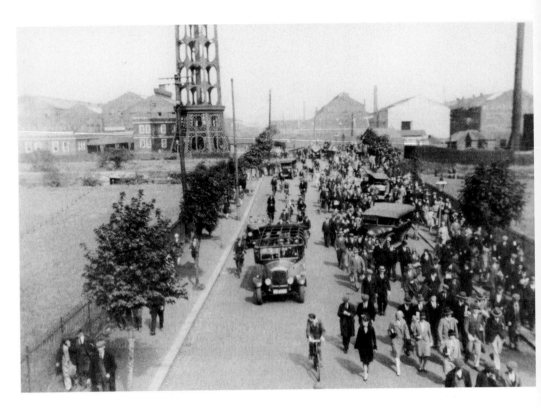

Workers leaving Metro-Vickers in 1927, with the water tower behind them.

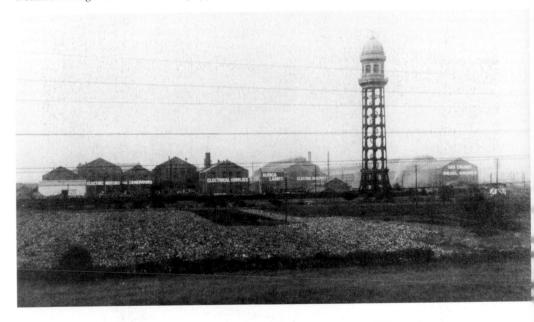

A distant view of the water tower and the works of Westinghouse/Metro-Vickers, showing the lettering on the buildings which advertise the various products of the factory: electric motors and generators, electrical supplies, aurica lamps, gas engines and diesel engines.

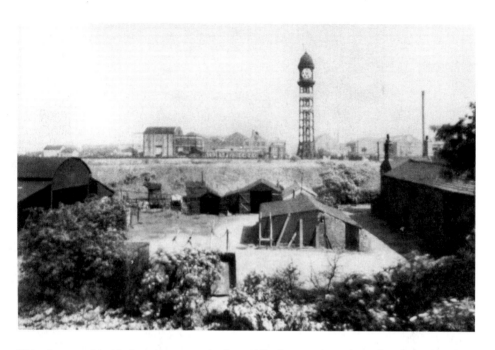

This photograph with the water tower in the middle distance dates from the 1920s.

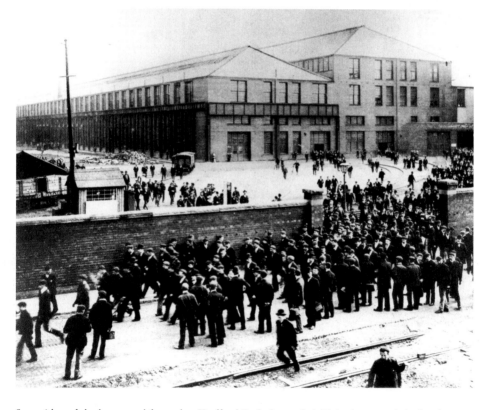

Some idea of the huge workforce that Trafford Park demanded. This photograph is dated 1903.

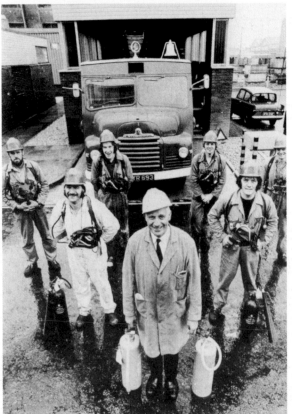

Above: Lancashire Fire Brigade on Westinghouse Road in Trafford Park.

Left: The Geigy Fire Brigade pose for the Stretford and Urmston Journal in 1975.

Chapter 5
The Social Scene

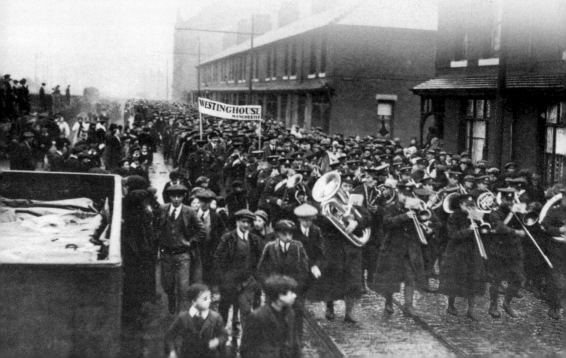

Overawed by the sheer size of the industrial estate, and the immensity of the factories, it is easy to overlook the fact that there were also many houses and an active local community within Trafford Park. The housing estate was established very early in the history of the Park, with the formation of Trafford Park Dwellings Ltd in 1899. This was an independent company at first, but by the 1920s it was regarded as an associated company of Trafford Park Estates. The residential development was intended to house key workers for the growing number of factories, since it was clear that although there was a sizeable workforce in the vicinity of the Park, there would be an influx from other areas as men and women came to seek jobs. Records show that people came from places as far away as St Helens and Liverpool to look for a job and also somewhere to live. It would have been impossible to commute over those distances during that period, so the establishment of a housing estate was a shrewd move on the part of the administrators of the Park.

Early photographs of the houses show regimented lines of terraces, with one side of the estate right up against the original Ford factory and the other sides bordered by fields. The grid plan was adhered to rigorously, so that people compared the layout with American cities. This American parallel was reinforced by the way in which the roads were named – those running north to south were called First, Second, Third and Fourth Avenue, and those running east to west were called Streets, and were numbered from First to Twelfth. However, there never was any Seventh Street, since the school and recreation ground lay between Sixth and Eighth Streets. For a short while, the workers who lived in the Village, as it came to be known, were in a semi-rural area, with large parts of the original parkland still unoccupied. There were walks through woods in the old park, some of the farms were still in evidence, and dairy herds were grazed on the fields. The boating lake formed an important part of people's recreational activities, not just for the workers in the Park but for visitors from other parts of the country. Eventually, the conservatory that had belonged to the Trafford family was re-erected on the west side of Third Avenue, and used as a cinema and assembly rooms.

Soon after the formation of Trafford Park Dwellings Ltd, amenities were brought to the area. Shops, churches and schools were built, and eventually a police station and a post office were provided by the Trafford Park Estates Company. The first churches and schools were hurriedly put up in corrugated iron. The Methodist chapel was the first to be built in 1901, followed by St Cuthbert's Church of England church in 1902, then St Antony's Roman Catholic church in 1904. The Ordnance Survey map of 1908 shows three churches ranged on the western side of the dwellings, running from north to south between Third and Fourth Avenues. In 1902, the first school was built – also in corrugated iron – earning it the name of the 'tin school'. It was built by the Stretford Urban District Council, and at the same time it was stipulated that a recreation ground should be laid out next to the school, but this was not completed until 1908, with two bowling greens and a tennis court. St Antony's Roman Catholic school was built in 1912/13, and the old tin school was replaced in 1914 by a permanent brick building.

Having catered for religion and education, there remained recreational pursuits to provide for, and this was dealt with by providing a pub. At the northern end of Third Avenue, where it met Ashburton Road, The Trafford Park Hotel was built in 1902, where beer was sold and meals were served. Since there were few other cafes or eating houses

within easy reach of the Village, the pub had a virtual monopoly on the trade. In the 1920s and 1930s, a children's playground, a park and a municipal swimming pool were added to the list of recreational facilities, but at the same time some features were lost – for instance, the conservatory housing the cinema was demolished, and the bowling greens and the tennis court disappeared.

The houses in the Village were graded according to size. Those on Eighth to Twelfth Streets at the northern end of the housing estate were larger, with three or four bedrooms, while those to the south were smaller. Some had gardens, but where these faced each other, the street between the houses was very much reduced in size, and when the roads were finally paved, the gardens disappeared. One of the surprising facts about the housing was that there were always vacant properties, and there were seemingly no long waiting lists for houses.

Trafford Park residents indulged in a variety of communal pursuits, such as the annual pageant and the Whit Walks, common to many northern industrial towns. Both St Antony's and St Cuthbert's churches organised Whit Walks, when everyone dressed up on Whit Sunday in their best and paraded through the streets with banners and bunting. St Cuthbert's also organised a trip on the Saturday before the Walks, usually by barge or by train, to nearby rural places, such as Lymm and Marple. Other festive occasions included the various Royal visits to Trafford Park – for instance, King Edward VII came to open the number nine dock on the Ship Canal in 1905, and on this occasion, arches were erected along the route, proclaiming 'Trafford Park is Awake'. On a later occasion, when King George and Queen Elizabeth toured the Park, one of the workers from a factory on Praed Road recounted how all the employees were allowed to line up outside to see the Royal couple passing by, and her friend whispered to her about the Queen: 'I see she's still wearin' that old 'at as I gave 'er last year!'. Apart from Royal visits, there were prize-giving ceremonies organised by the various works, and sports clubs were formed at the schools and the works.

The end of the Village came slowly, beginning in the 1970s when Stretford Council started to clear the houses. The last annual pageant was held in 1976 by the residents who were about to be moved away. The 1990s saw much redevelopment work in the Village, when the clinic and the library buildings were refurbished and put to other uses, and the retail block on Third Avenue was modernised. On the Trafford Metropolitan Borough street map, there is a trace of the street plan, bounded by Europa Way on the east side, by Mosley Road and Praed Road on the west, and by Westinghouse Road and Village Way on the north and south.

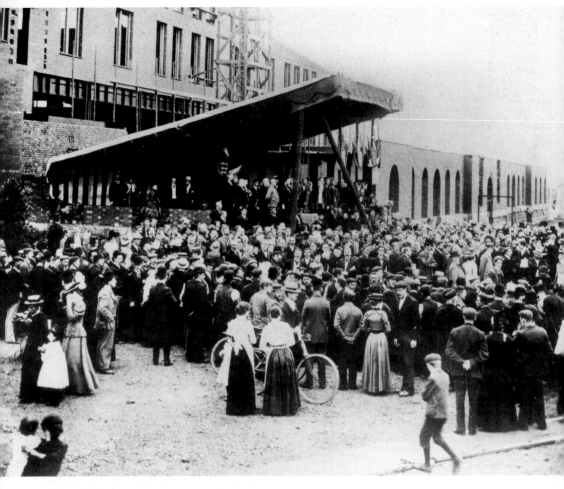

Laying the foundations at Westinghouse in 1901.

Opposite above: Awards and prizes in the pattern shop at Metropolitan-Vickers in the 1920s.

Opposite below: The Trafford Park entrance in 1905, on the occasion of the visit of King Edward VII.

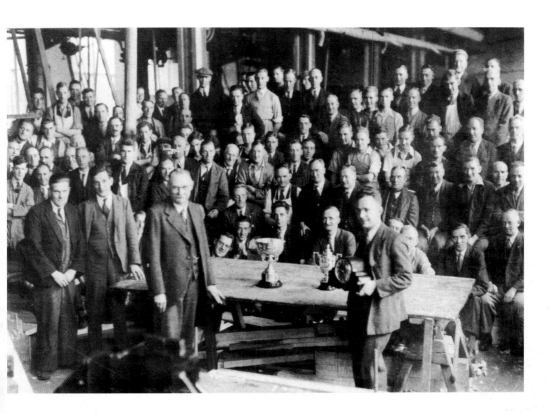

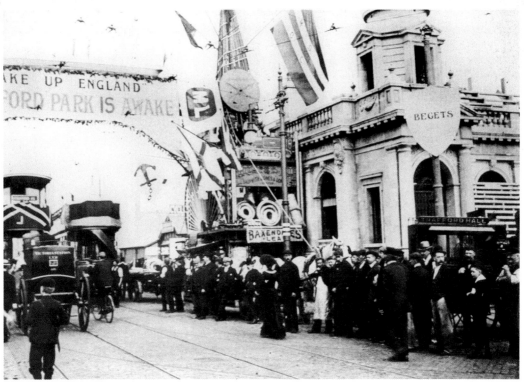

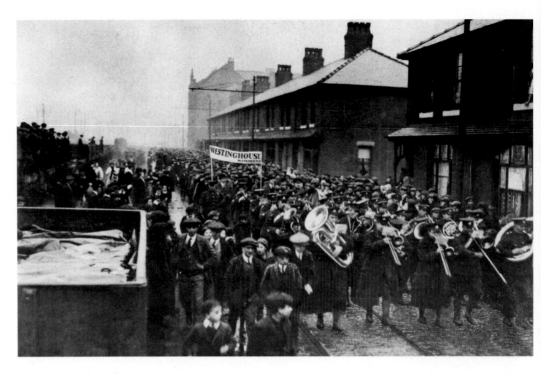

Volunteers for the armed services from the Westinghouse works, 1914.

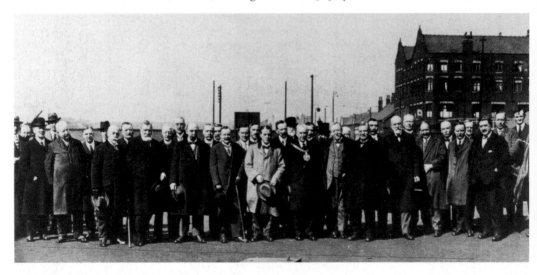

An inspection at Westinghouse by dignitaries of the local authority in 1917.

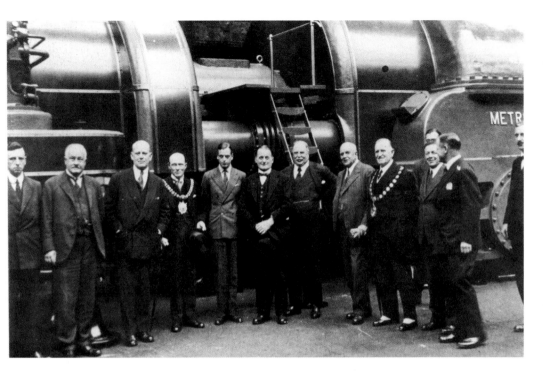

Council dignitaries and Metropolitan-Vickers managers with HRH Prince George.

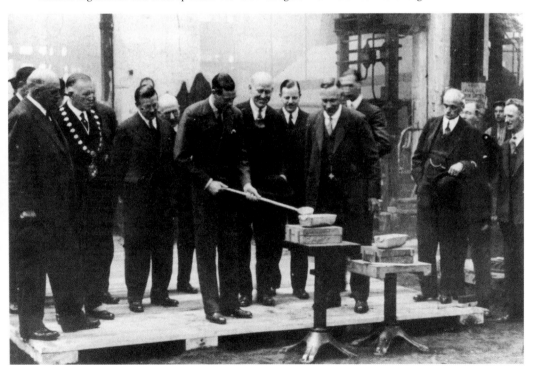

HRH Prince George tries his hand at the Metropolitan-Vickers works, 1931.

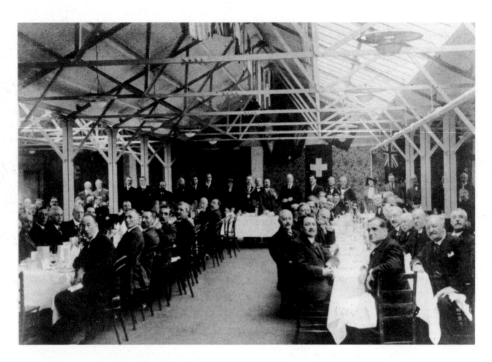

A foreign commercial mission luncheon in March 1921.

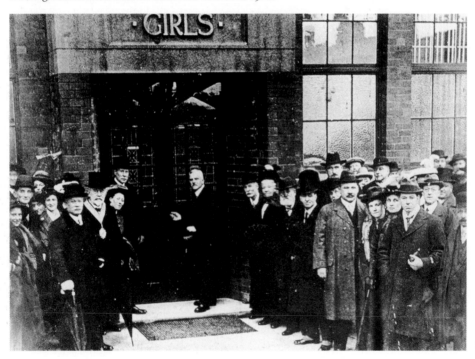

The opening of the Trafford Park Council School.

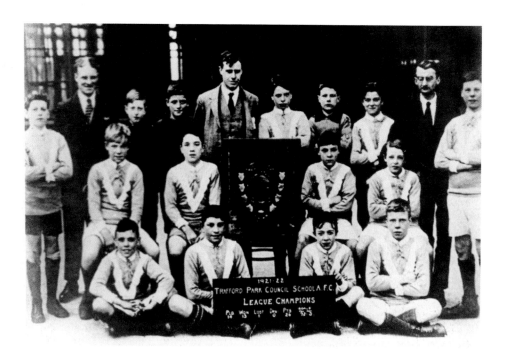

The Trafford Park Council School football team in 1920 or 1921.

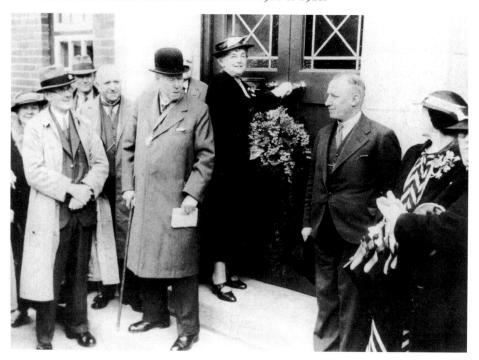

Councillor Mrs Bagley opens the Trafford Park Clinic in June 1936. The clinic and the library shared the same building and were opened at the same time.

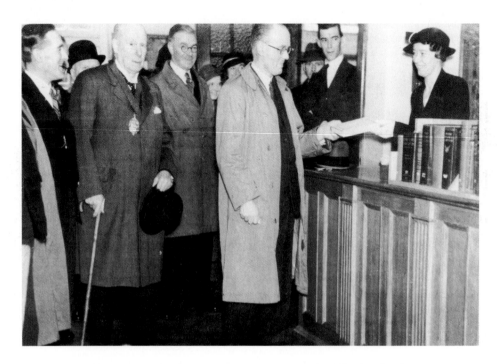

Alderman Wardle borrows a book at the opening ceremony of Trafford Park Library in June 1936.

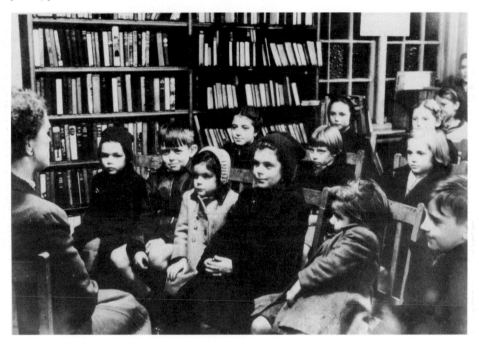

Storytime in Trafford Park Library.

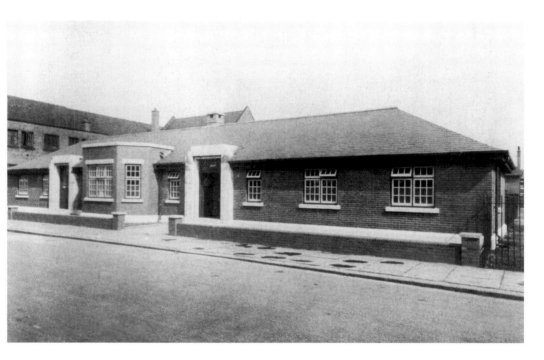

The exterior of the library and clinic.

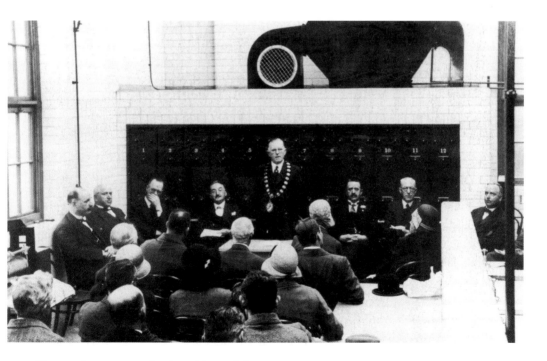

The opening ceremony for the public wash house in 1931.

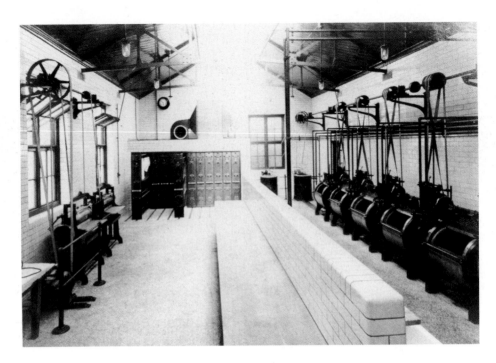

The interior of the Trafford Park public wash house, with all the modern conveniences of the 1930s.

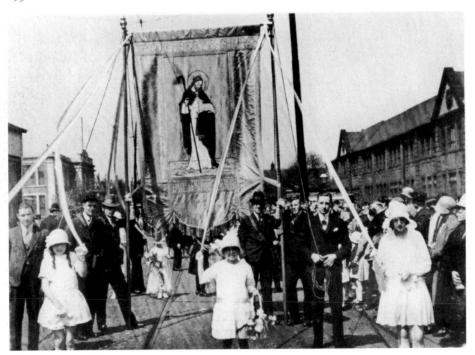

St Cuthbert's Whit Walks, *c.* 1930.

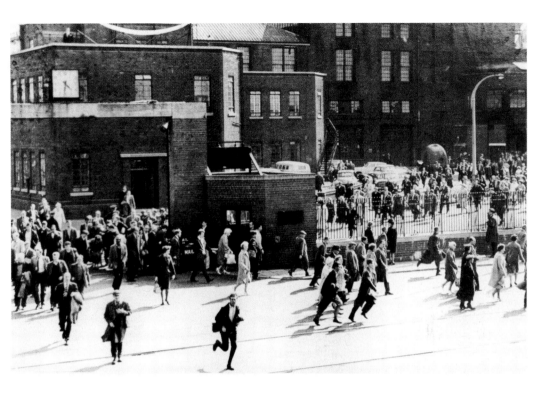

Workers at AEI finish work and are ready for their annual holidays, 14 August 1963.

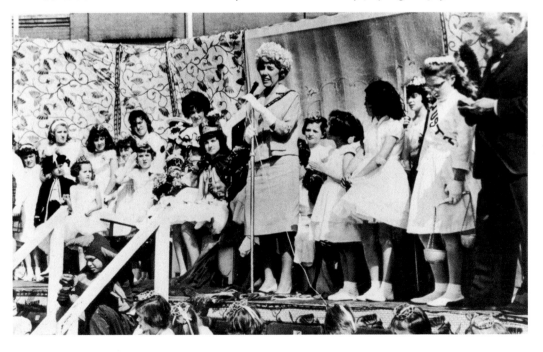

Speeches at the gala in 1963.

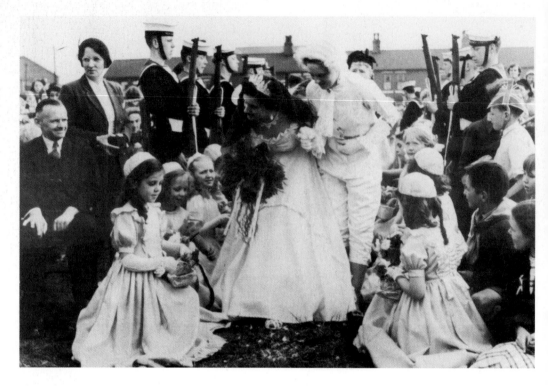

Rose Queen at Trafford Park carnival.

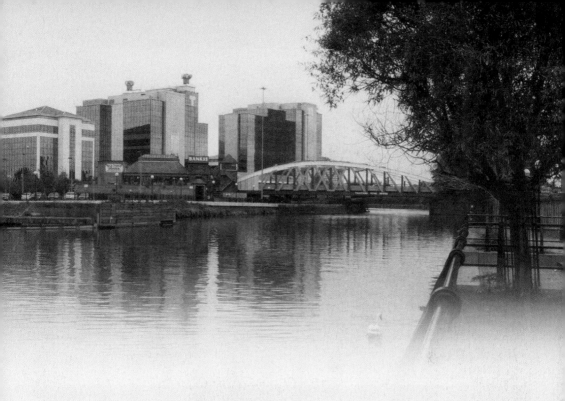

Chapter 6
Trafford Park
Today

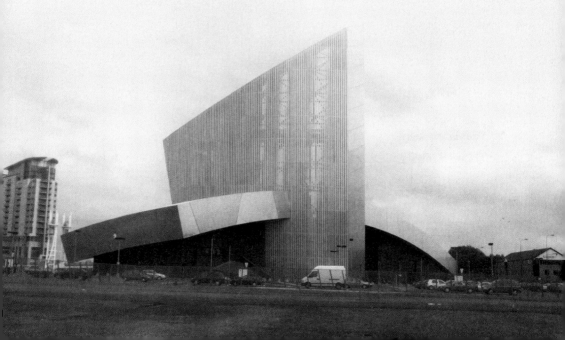

Trafford Park today has undergone many changes since it became the 'Workplace of the World' during the 1930s and 1940s. Gone are the many factories with workers rushing to and from their place of work, gone are the streets and houses where they lived and socialised, but despite these changes, Trafford Park as an industrial area has managed to adapt and, as such, it has survived. It was during the late 1960s and '70s that the success of Trafford Park as a world marketplace declined, as companies tried to survive the economic gloom that pervaded the whole country. Trafford Park was a victim of its own success, as factories built at the turn of the century were fast becoming outdated and uneconomical to run. Drastic action from employers reduced the workforce and strikes were frequent, with competition from abroad only increasing the problem. Eventually, many companies were forced to close or move out to other areas. Many of the terraced houses became deserted as people moved away, and between 1976 and 1982 they were demolished as part of a statutory housing act.

Measures were taken to try and stem the flow of this decline, and it was during this period that the Trafford Park Industrial Council (TRAFIC) was formed to try and bring some life to a failing industrial marketplace. This organisation introduced new schemes to improve the appearance of the area after companies left empty buildings, which gave the area a feeling of abandonment. During the 1980s, Trafford Park was selected as an Enterprise Zone and, with the formation of the Trafford Park Development Co., it was hoped that new life would be breathed into the area. The Village was developed into an area for small businesses, with banks and associated infrastructure developing alongside. In 1982, Walter Kershaw was commissioned to paint a mural on the old Liverpool Warehouse. The mural, which depicts the many industries that made up Trafford Park, was replaced with another version in 1993 and can be seen as you approach Trafford Park from Manchester.

Many new types of businesses have now made their home in Trafford Park and are thriving. The skyline is dominated by two of the most successful enterprises – that of the Manchester United Football Stadium (Old Trafford) and the Trafford Centre, both of which can be seen for some miles. These two enterprises mark the success that has transformed the area and, as a result, has created many new jobs. A Euro terminal, hotels, pubs and supermarkets (such as Asda and Costco) have become established, and the area is undergoing continual development. Wharf side has been redeveloped and a major achievement of the 1990s was the siting there of the Imperial War Museum North-West, which has brought a modern face to Trafford Park with its unique award-winning design.

Trafford Park has suffered badly over the last hundred years and after the boating lake was closed, it was used for tipping slag material from the Taylor Brothers factory. In 1974, an idea was put forward by TRAFIC that the lake should be cleaned out and used as an ecology park. This idea was developed, and in 1990 the area was opened to the public, with the lake managed by the Salford and Trafford Groundwork Trust. The area is now proud to boast thriving flora and fauna and is an area well worth a visit. There is also a visitor centre at St Antony's, where visitors can find out how life in the Park has changed.

Trafford Park over the last hundred years has undergone both success and failure. Many people have contributed to its success, including those who have worked there during the last 107 years. During the Second World War, the manufacturing companies of Trafford Park were instrumental in keeping the country running, and the sheer determination of those who worked there during this difficult time deserve a special mention. Today, Trafford Park encompasses the varied aspects of the modern age, from a retail shopping mall to a heritage centre, and as such has guaranteed its future for many years to come.

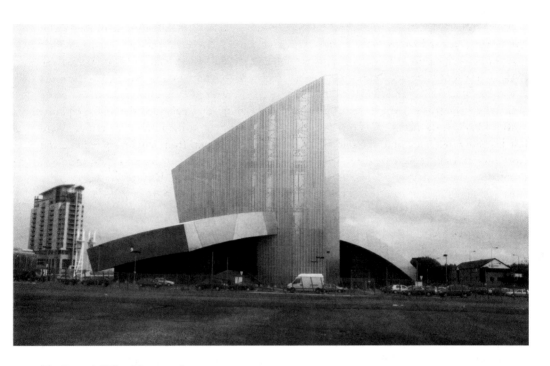

The Imperial War Museum, June 2003.

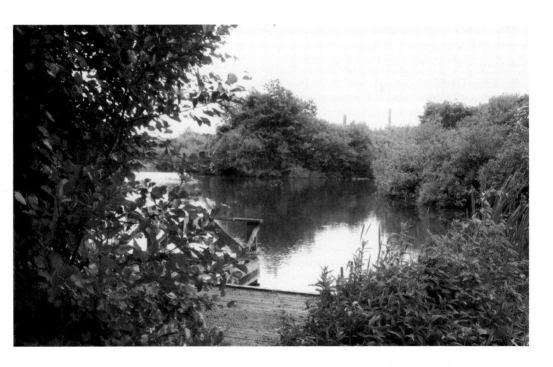

This photograph of Trafford Park Lake, taken in June 2003, captures the peace and tranquility surrounding the lake today. It is hard to imagine that it is surrounded by industry, and it is well worth a visit.

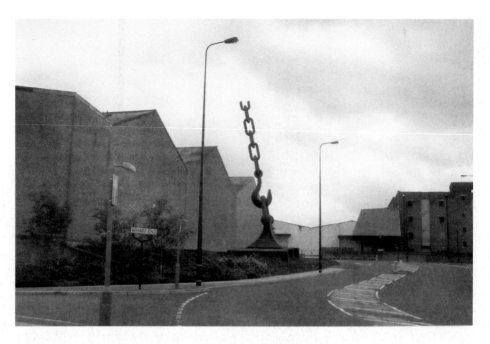

One of the two sky hooks situated at Wharf End, June 2003.

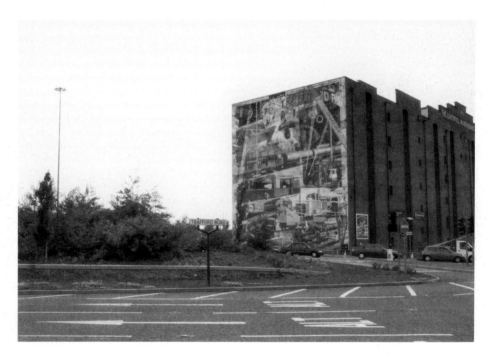

The Trafford Park mural reflects the industry that makes up Trafford Park. Taken in June 2003, this is the second mural to be painted and can be seen as you approach Trafford Park from the city of Manchester.

The Trafford Park Hotel after refurbishment, June 2003.

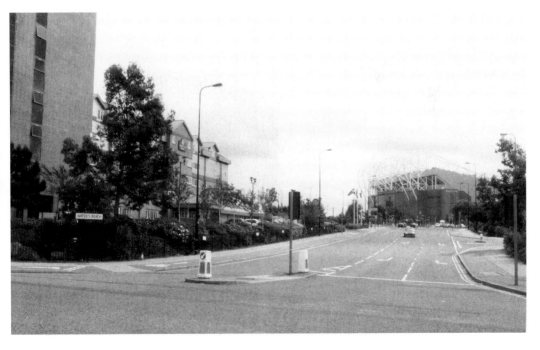

Manchester United's football ground from Waters Reach, June 2003. The Manchester United Hotel can be seen on the left of the photograph.

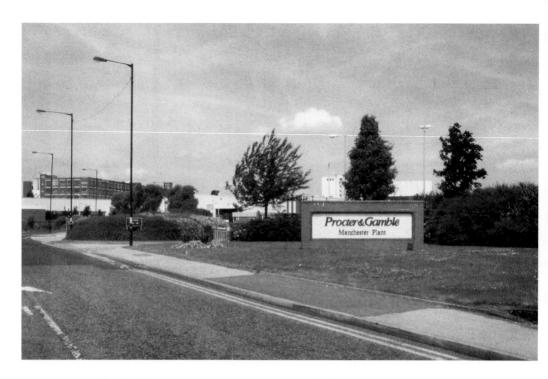

Proctor & Gamble's building now stands in the area where Trafford Hall once stood. This photograph was taken in June 2003.

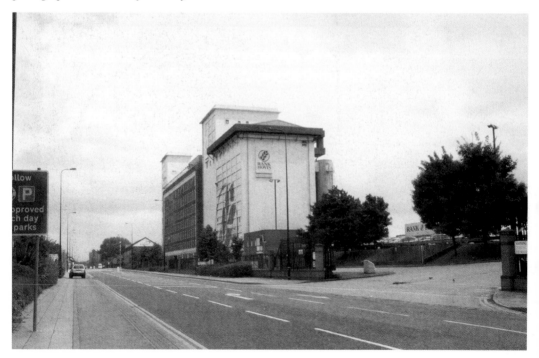

Rank Hovis, June 2003.

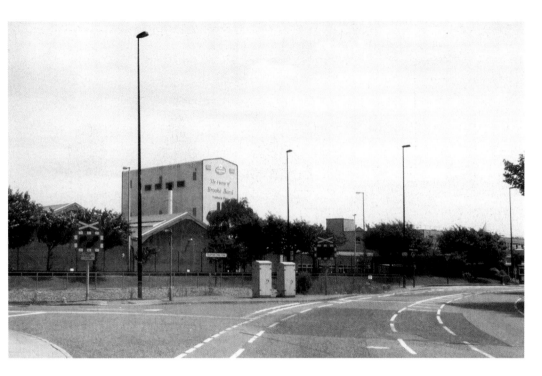

Brooke Bond, June 2003.

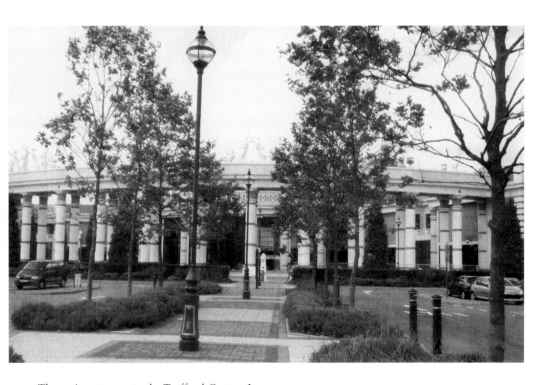

The main entrance to the Trafford Centre, June 2003.

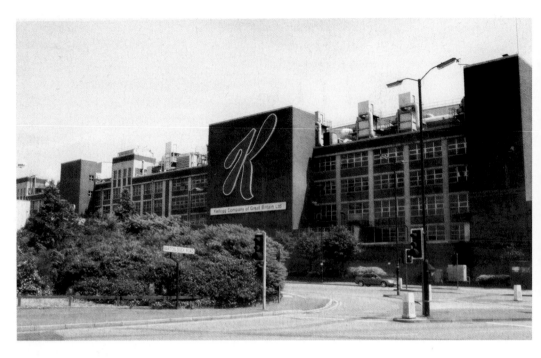

Kellogg's, from the corner of Barton Dock Road, in June 2003.

The tomb of Marshall Stevens in St Catherine's churchyard, June 2003. The churchyard is now sadly overgrown, but the tomb is clearly visible and marks the resting place of Marshall Stevens, who was one of the main contributors to the development of both the Manchester Ship Canal and Trafford Park.

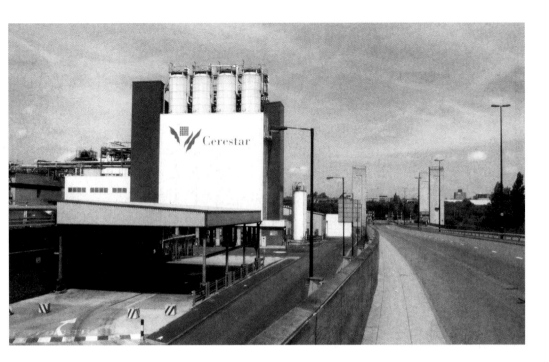

Cerestar, looking towards the Centenary Bridge, June 2003.

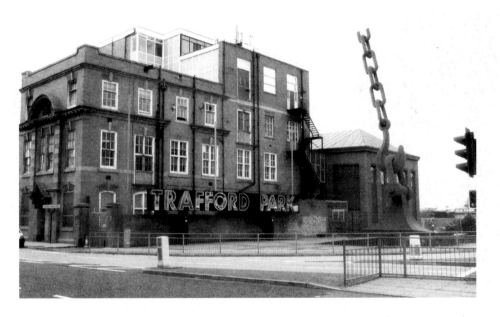

The entrance to Trafford Park, June 2003.

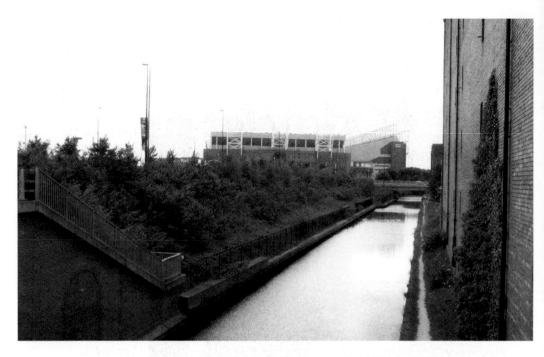

Looking down the Bridgewater Canal towards Manchester United's ground, June 2003.

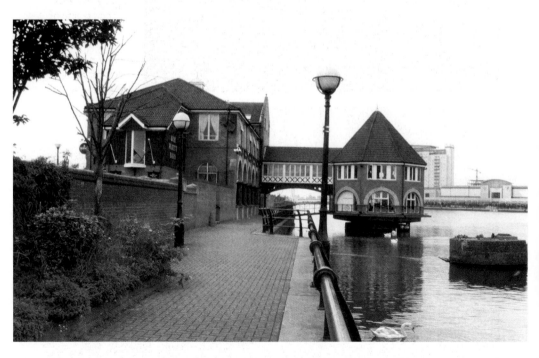

A side view of Samuel Platt's Pub, taken from the Manchester Ship Canal embankment in June 2003.

Opposite below: Trafford Park Village, June 2003.

Left above: The gates to the former Westinghouse Company situated in Moss Road, Stretford. Sadly, this is all that is left of the former company, which also traded as Metro-Vickers, AEI and GEC, and at one time was one of the largest employers in Trafford Park. The building behind is a warehouse.

Left middle: Westinghouse Road, looking towards the former site of Westinghouse, June 2003. The area is currently being redeveloped as small business units.

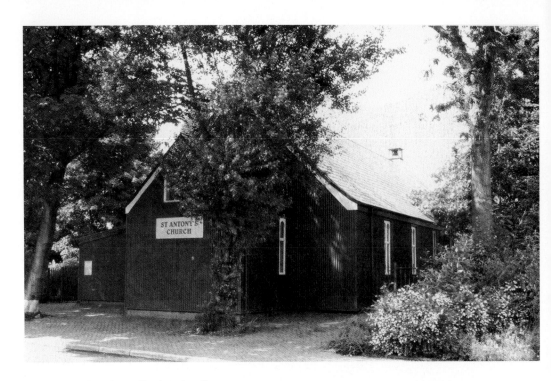

St Antony's church, Trafford Park Village, June 2003.

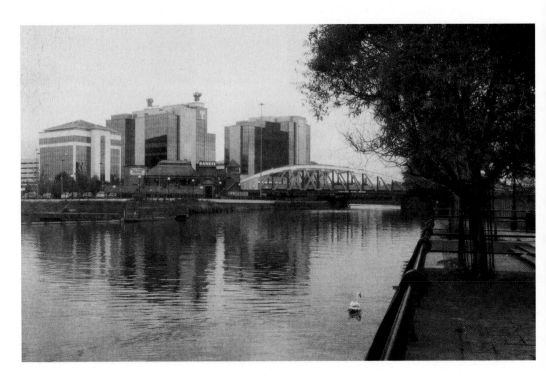

Trafford Road Bridge, looking towards Salford, June 2003.

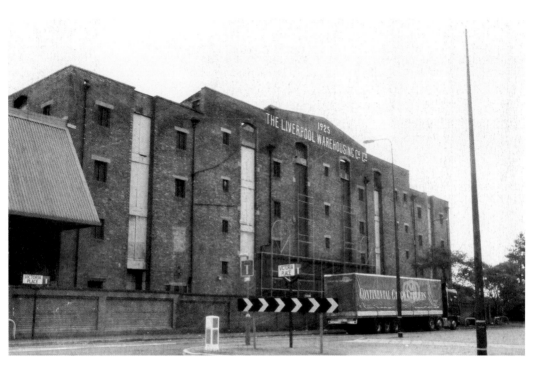

One of the existing warehouses, which is still in use today, June 2003.

Westinghouse Road, looking towards the air freight terminal, June 2003.

Bibliography

Bailey, John E., *Old Stretford*, 1878.

Chetham Society, *History of Stretford Chapel (First Series vols. 42 and 51)*, 1902.

Gill, Dennis, *Transport Treasures of Trafford Park*, 1973.

Green, Daniel, *CPC Europe: a Family of Food Companies*, 1979

Hayes, Cliff and Sylvia, *Britain in Old Photographs: Stretford*, 1997.

Illustrated Account of the Work of the British Red Cross Society During the First World War, 1916.

Kellogg's Fifty Years of Making Sunshine 1938 to 1988, 1988.

Macbride, Vincent, *Trafford Park* (a thesis).

Massey, Samuel, *A History of Stretford*, 1976.

McIntosh, Ian, *Life and Work in Trafford Park*, Lancashire and Cheshire Antiquarian Society, 1994.

McIntosh, Ian, "'It Was Worse Than Alcatraz"; Working for Ford at Trafford Park' in *Manchester Metropolitan-Vickers Electrical Co. Ltd 1899 to 1949*, 1949.

Nevell, Michael, *The Archaeology of Trafford*, 1997.

Nicholls, Robert, *Trafford Park: the First Hundred Years*, 1996.

Peers, M.W., *History of the Manchester Golf Club*, 1982.

Redhead, Michael, *Stretford in Times Past*, 1979.

Regional History Review (vol. IX), 1995.

Rimmer, Alfred, *Summer Rambles Around Manchester*.

Stretford Local History Society, *Stretford in Old Picture Postcards*, 1992.

Trafford Park Development Corporation, *Life and Changes in the Park: A Resource Pack*, 1995.

Trafford Park Development Corporation, *Trafford Park Centenary 1896-1996*, 1996.